IMAGES
of America

BARSTOW

IMAGES
of America

BARSTOW

Christine Toppenberg and
Donald Atkinson

ARCADIA
PUBLISHING

Published by Arcadia Publishing
Charleston, South Carolina

Printed in the United States of America

Library of Congress Control Number: 2015938947

For all general information, please contact Arcadia Publishing:
Telephone 843-853-2070
Fax 843-853-0044
E-mail sales@arcadiapublishing.com
For customer service and orders:
Toll-Free 1-888-313-2665

Visit us on the Internet at www.arcadiapublishing.com

This book is dedicated to the people of Barstow who live in, love, and preserve the Mojave River Valley as rich, precious, and living.

CONTENTS

ACKNOWLEDGMENTS

Without hesitation and fancy words, I owe Pat Schoffstall unlimited appreciation for her initial guidance, wisdom, and experience. The project began several years ago when I found and contacted the Mojave River Valley Museum in my search for the places of my own life story in Barstow. Pat found those places for me without delay. And when I learned that books were being written about high desert towns for Arcadia Publishing's Images of America series, I sent the publishers an e-mail, and the contract to do this book landed in my surprised and willing lap.

I want to especially sincerely thank Judy and Nick Borkman for graciously lending me writing space in their aerie home near Barstow for the duration and Judy for reading, proofreading, and hugs down the backstretch.

Much appreciation and gratitude goes to these Barstow folks for their time, attention, information and advice: Mayor Julie McIntyre Hackbarth, Clifford J. Walker, Kate Rogers-Boyd, Bob Hillburn, David Mott and Steve Smith at the Mojave River Valley Museum, Deb Hodkin and Bill and Lavella Tomlisons at the Route 66 Museum, Elena Rivera and Joseph Hisquierdo at the Barstow Chamber of Commerce, Fran Elgin at Victor Valley College Archives, and all those who contributed photographs from their personal collections.

And finally, I am grateful without limit to Donald Atkinson for joining me on this project. I asked him along the way to take a few photographs in Barstow, and he ended up being designated driver and expert Barstow trail guide, and then full partner on the project as the master photograph technician and, lucky for me, the missing half of my brain.

INTRODUCTION

People have been following trails to Barstow for thousands of years. Tribes of prehistoric people inhabited the Mojave Desert region as long as 3,000 years ago. They hunted and fished and gathered turquoise. They left barely discernible footprints along faint pathways as they traveled as far away as the Mexican territory to trade goods.

The written history of the Mojave Valley traces back to the 1700s and the missionary excursions of Francisco Garcés. He followed those first faint footpaths to the Mojave River Valley and from there across the desert near Barstow on his way to Spanish missions beyond the mountains of California. Waves of incomers followed his footsteps into the desert and on to the river valley.

Jedediah Strong Smith was one of those path followers. He trapped and explored his way west over the same trails in the 1820s. He too was followed, and the trails became deeper with the prints of hooved animals brought to the New World on European ships. Traders from New Mexico brought their business to these trade routes. Horses became a most valuable coin. And camels were tried out as beasts of burden. John Charles Frémont joined the action by the mid-1840s. And a Mormon battalion took the first wagonload of goods from the West Coast to Salt Lake City, Utah, over the ever-widening trails around and through the Barstow area.

Mormon colonists traveled through the Mojave River Valley on their way to San Bernardino. Covered-wagon caravans began carving the trails into rutted roads. As the Civil War took shape, civilians formed volunteer armies and established forts, including Camp Cady near Newberry Springs. Silver ore was discovered in the calico-colored hills, and the famous Silver King Mine was established. Robert Waterman and John Porter filed the claim that became the Waterman Mine.

The railroads came into the valley to carry the ore and transport more incomers to take up the huge increase in jobs in the mines and on the railroads. Daggett was started up as a transportation center. Borate had been discovered in Death Valley, and operations spread to Calico and through Barstow to Boron. Rail lines crisscrossed the valley and steamed up the Cajon Pass and back, through a junction known as Waterman Junction, soon renamed Barstow.

Automobile travel was not far behind, as intrepid souls began to drive their new experimental horseless vehicles over the dirt roads alongside the railroads. One of those dirt roads was named the National Old Trails Highway. More trails became highways for automobiles. Macadam surfaces began to appear on those highways. US Highway 66 was inaugurated, as well as US Highway 91. And those two roads met up on Main Street Barstow. People were streaming in on those highways, and Barstow was launched. The growth was exponential.

Enhancing Barstow's phenomenal growth was the establishment of two major military bases. One was the US Marine Corps Supply Center and the other was Camp Irwin. Both were installed in proximity to Barstow. Goldstone Tracking Station was developed, adding more jobs and bringing the area into the space age.

Barstow had laid down its first township along the railroad tracks near the Mojave River. This became a major railroad junction. Businesses grew up along the tracks. Pres. Theodore Roosevelt visited Old Town Barstow and regaled the residents with his enthusiasm for what he saw there. When some of those buildings were repeatedly lost to fire, the citizens of Barstow gathered up and formed a fire department and made quick work of moving the town and buildings to a new center, up onto Route 66, which became Main Street in Barstow. And it continued to grow. At one time, there were five service stations at the junction of US Highway 91 and US Route 66.

The next turn of events was ironically inopportune because of that growth. So many automobiles were traveling across Southern California and the country as a whole that plans were made to improve roads through changing routes to circumvent downtowns. Barstow was hit hard when Interstate 15 was built, bypassing Main Street, taking through traffic up the hill and around the town and its businesses. The new highway was faster and wider, and some establishments in downtown Barstow lost up to 90 percent of their business. The people of Barstow had to reinvent themselves, and they did. Barstow slowed down but thrived even though many neighboring towns have declined into shadows of the towns they once were. In addition to economic assets such as farms, ranches, military bases, mines, and railroads, Barstow developed a healthy tourist industry fed by the worldwide public's fascination with Route 66 and the glittering, movie star–studded lifestyles of the 1950s, which Barstow has experience with by the trainload.

One

HISTORY

The story of the early emergence of the city of Barstow, California, begins long years ago along the enigmatic Mojave River in the middle of the ancient and formidable Mojave Desert. Evidence of prehistoric people inhabiting this vast desert is found inscribed on rocks scattered throughout the area.

Spanish explorers arrived on the continent and traveled through the area, leaving their influence behind. They were soon followed by explorers from the East, who used the same routes. Gold, silver, and borax deposits were discovered throughout the area. The young United States sent its militaries into the region. Railroad companies stretched their lines through and established stations along the way. A way station called Waterman grew into an important rail yard, connecting major rail lines westward. The settlement that developed around the railhead was renamed Barstow after Santa Fe executive William Barstow Strong. Homesteaders and fortune-seekers arrived and stayed. Barstow thrived and grew.

During the 1940s and 1950s, while military and railroad industries flourished, Barstow became a popular stopover for travelers, commercial carriers, and, most exciting, droves of Hollywood entertainers, as a hideaway and rest stop between the Los Angeles basin and Las Vegas. The construction of a major freeway in the 1960s changed the face of the entire desert, rendering the vibrant towns along the old highway into slower, quieter burgs. Some have become ghost towns of themselves.

However, a few towns discovered their reserves of creativity and perseverance, carved new economic riches such as film location and tourist trade, and survived and thrived as Barstow has. Fortunately, Route 66 remains intact along Barstow's Main Street. Several major historical sites have been lovingly maintained or restored, making Barstow a rare historical respite in the middle of an otherwise long trek across the still sparsely populated and vast wilderness of the Mojave Desert.

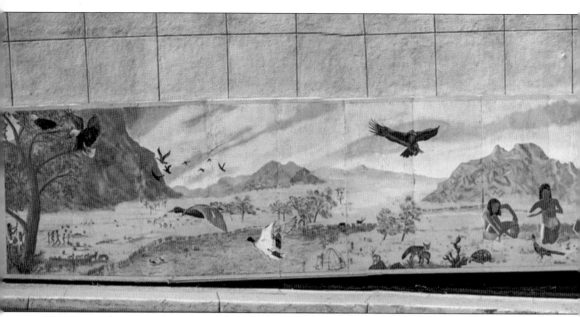

Native populations such as the Mohave, Chemehuevi, and others inhabited the Mojave Desert for thousands of years before European explorers arrived. Remnants of villages and stone fishing traps, stories passed down through generations to the present, and petroglyphs visible on rock

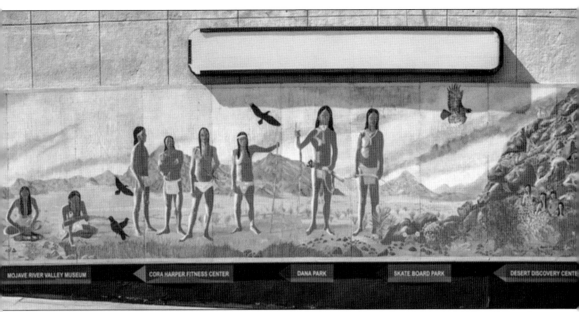

formations give today's historians sparse clues to their lives and communities. Capt. John C. Frémont, the first Anglo known to enter the interior of the Mojave Desert, recorded his first meetings with the Mohave tribe in 1844. (Courtesy of Main Street Mural Project.)

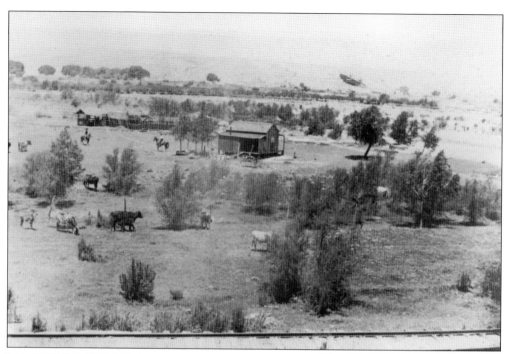

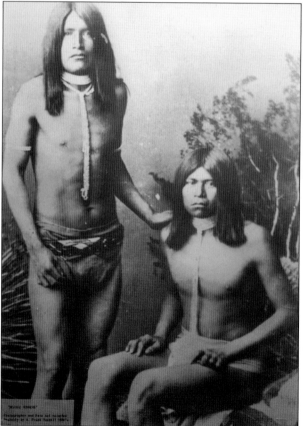

The Waterman Ranch, pictured here in the 1880s, was nestled between the hill later called B Hill, the Mojave River, and the early railroad tracks. It was founded by Robert Waterman, 17th governor of California. He was an early and successful silver mine owner. The new town was named Waterman after him before it was renamed Barstow. (Courtesy of the Mojave River Valley Museum.)

Early native people of the Mojave River Valley used manpower to carry messages from village to village across the vast dry desert. Using simple moccasins draped around their shoulders when the going was rocky, they primarily ran barefoot. When Capt. John Frémont met these runners in the 1840s, he named the surrounding desert and its river Mohave after his understanding of what the natives called themselves. (Courtesy of the Smithsonian Museum.)

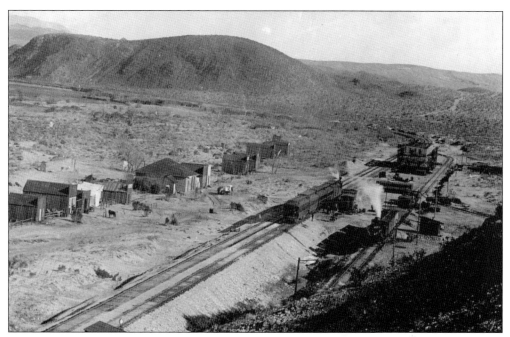

The oldest known view of the original town of Barstow is depicted in this 1896 photograph. The first depot and a new town are under construction. This area would become a major railroad switching station connecting all major rail lines in the Southwest as well as the location of the first of the Harvey House chain. (Courtesy of the Mojave River Valley Museum.)

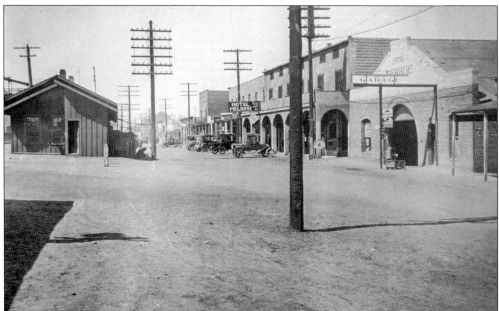

This was Barstow's main business street in 1912. A new and growing town had sprouted at the rail yard. The original Melrose Hotel was built here, along with a garage. These first businesses were soon joined by others. The first transcontinental road from New Mexico was routed through Barstow in 1913, and increasing traffic contributed to the budding economy. (Courtesy of the Mojave River Valley Museum.)

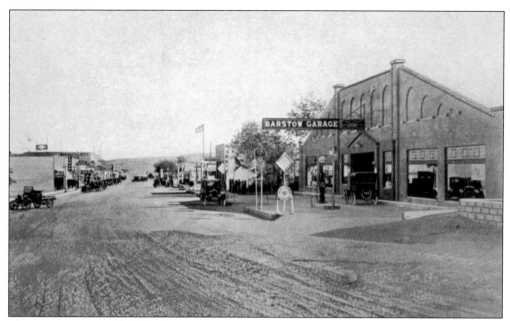

The Barstow Garage building on the right still stands today. The photograph, taken before the 1926 establishment of the US Highway System, marks the approximate midpoint of the 315-mile stretch of highway that would become the final portion of Route 66, from Needles to Santa Monica, California. (Courtesy of the Mojave River Valley Museum.)

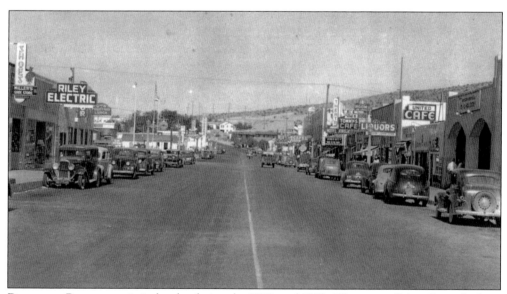

Downtown Barstow was in its heyday during the 1940s and 1950s. This view of Main Street looking to the west shows one of the most famous passages of the original Route 66. Businesses were thriving thanks to the influx of well-paid laborers attracted by military base construction, major railroad operations, ranching, and mining. (Courtesy of the Mojave River Valley Museum.)

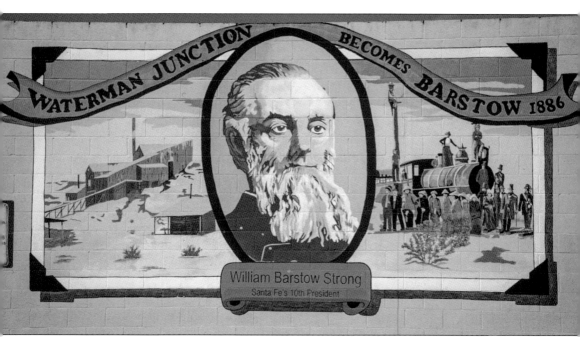

Several railroad lines connected in Barstow in 1885, and the junction was named Waterman for the governor, who also owned Waterman Mine and a mill in the area. The city of Barstow was named in 1886 after William Barstow Strong, the 10th president of the Atchison, Topeka & Santa Fe (AT&SF) Railway lines. Strong's influence on the developing city is commemorated here in one of the giant murals created along Main Street. (Courtesy of Main Street Mural Project.)

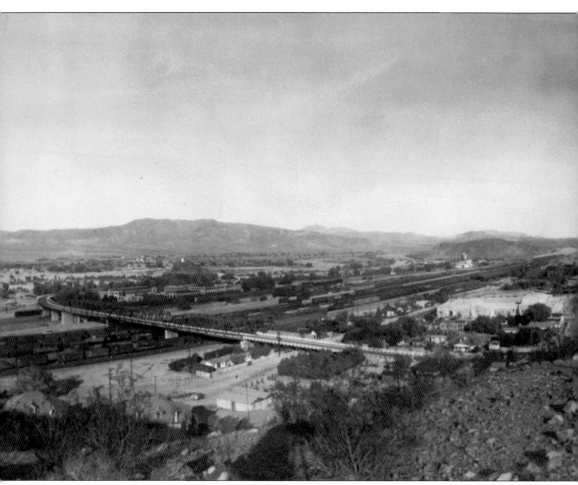

This panoramic photograph taken from high on B Hill offers a 1920s view of a Barstow decades old. The bridge over the rail yards leads off to the left and curves around the depot area and the original Harvey House. Waterman School is the large white edifice at center left. The growing town of Barstow lies to the right; most structures are small houses of whitewashed plaster or stone.

The bridge roadway is Highway 91 from Las Vegas to the northeast. The road will pass to the right through the village of homes and meet Barstow's Main Street, which will come to be known to this day as a Route 66 Main Street. (Courtesy of the Mojave River Valley Museum.)

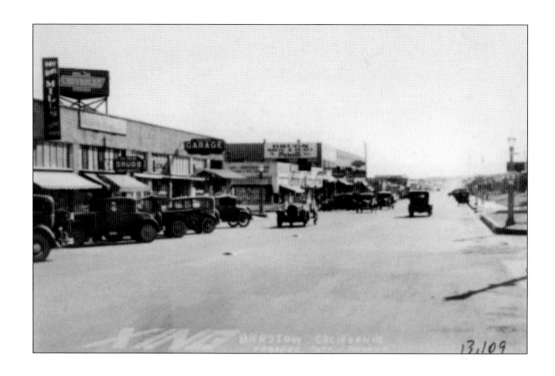

In the 1931 photograph above, Barstow's new Main Street has become a major thoroughfare. With the endless open acres of the Mojave Desert surrounding the growing town, there was no limit to the generous width of streets like this one. Pictured below is Main Street at First Street in 1938 with a fresh coat of painted lines. The businesses along this section of the original Route 66 were thriving, including the Standard station on the left, which reportedly pumped more fuel than any other Standard station in the country. The building still stands long after the station left. (Both, courtesy of the Mojave River Valley Museum.)

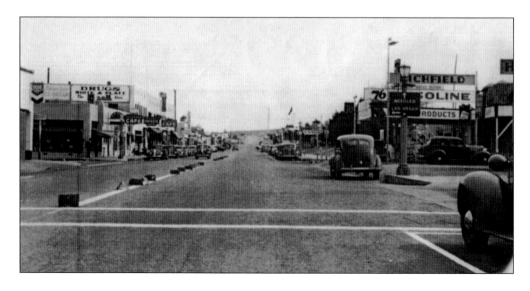

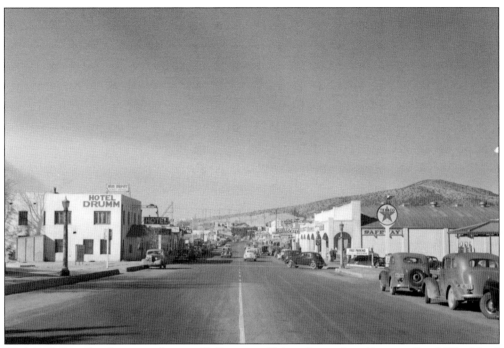

With B Hill in the distance, this is a 1940s view of Main Street from Barstow Road. The Hotel Drumm sits across from the Texaco station and the Safeway market. The Melrose Hotel greets travelers just down the street. (Courtesy of Huntington Library.)

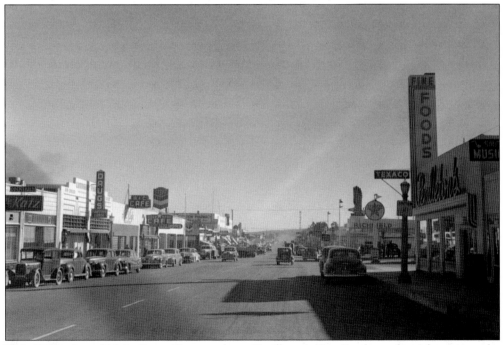

This 1940s view of Main Street Barstow shows Pendleton's Fine Foods on the right. Across the street on the corner of First and Main Streets are the Katz Bar and the Standard Oil station. In the distance is the Richfield Tower at the Beacon Hotel. (Courtesy of Huntington Library.)

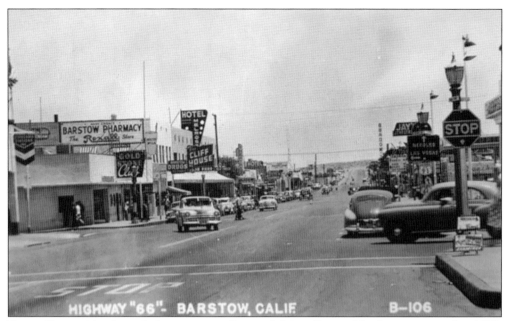

Route 66 ran right through downtown on Barstow's Main Street. The businesses in this 1950s photograph thrived on a steady stream of travelers between Las Vegas and the growing Los Angeles metropolis. Additionally, the area's population was steadily increasing as job opportunities mushroomed at three expanding military installations, the major railroad industrial hub, and mining interests. (Courtesy of the Mojave River Valley Museum.)

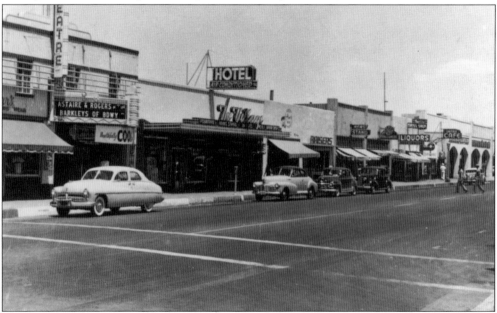

Route 66, perhaps the most famous highway in the world, runs directly through Barstow. In this iconic vintage photograph, the Standard station holds down the far corner of Main Street and a liquor store, hotel, and indoor theater can be seen. These buildings still house businesses today and provide travelers on old Route 66 a rare historical respite. (Courtesy of the Mojave River Valley Museum.)

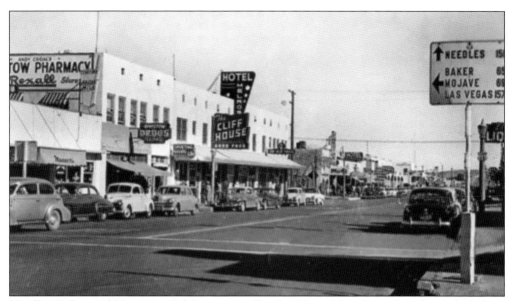

Needles, Baker, and Mojave in California, as well as Las Vegas, Nevada, are less than a day's drive from Barstow. By the time this photograph was taken, in the 1940s, the town had become a central hub of several important highways and was a handy as well as necessary rest, shop, and refuel stop halfway between Las Vegas and Los Angeles. (Courtesy of the Mojave River Valley Museum.)

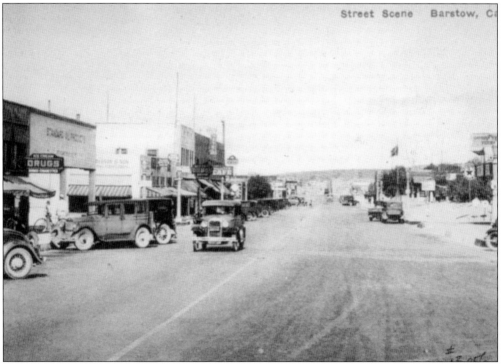

A very early Barstow street scene is depicted in this vintage photograph. It was probably taken in the mid-1920s, about the same time as the new Route 66 highway was being established. Fortunately for the economic good of Barstow, the new highway was routed to pass right down this street. (Courtesy of the Mojave River Valley Museum.)

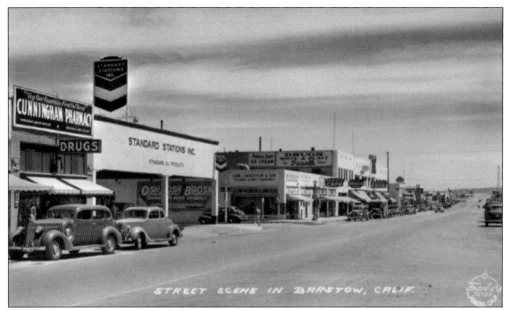

Burton Frasher was one of the most prolific photographers of the early to mid-20th century. His landscape and architectural postcards were distributed all over the world. A good collection of these images resides in the Mojave River Valley Museum archives in Barstow. This is one of Frasher's many 1940s depictions of Barstow's Main Street. (Courtesy of Pomona Public Library.)

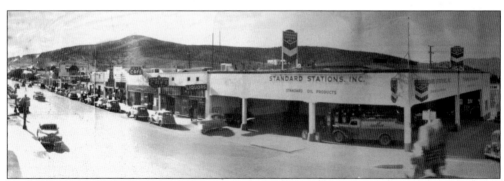

This 1940s photograph is a panoramic view looking toward the west along Barstow's Main Street from the intersection with First Street. The uniquely open architecture of the huge, completely covered Standard service station stands out as an iconic Barstow landmark. The structure remained intact and harbored commercial enterprises for many decades. (Courtesy of the Mojave River Valley Museum.)

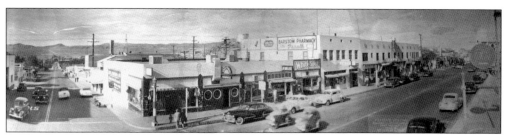

Barstow is displaying its thriving Main Street in this 1940s panoramic view. Businesses are benefiting from a growing interest in automobile travel, and highways are being paved to better connect the eastern states with the attractions of the West Coast. Fortunately, most of these roadways pass through and interconnect in the middle of Barstow. (Courtesy of the Mojave River Valley Museum.)

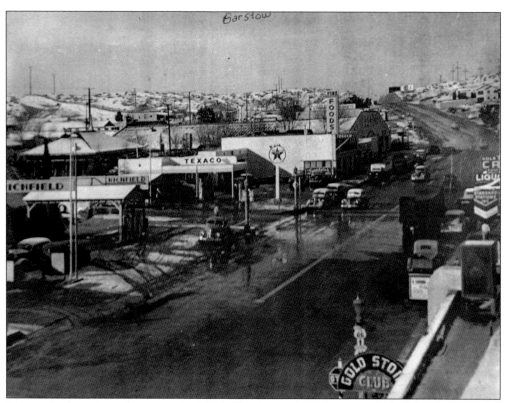

Tire tracks show through snow at the Richfield station, and snow covers the hills behind Barstow's East Main Street in this 1940s photograph. Also visible here are the three filling stations, all on one corner, revealing automobile travelers' high demand for gasoline at this halfway point between Las Vegas and Los Angeles. (Courtesy of the Mojave River Valley Museum.)

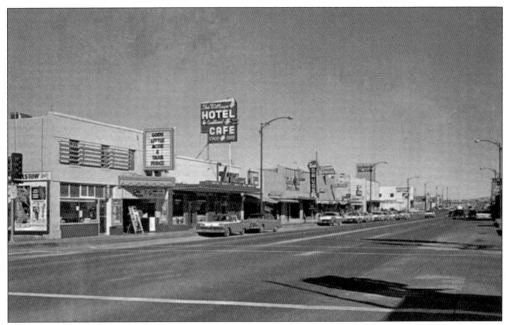

The theater in this 1958 photograph of Barstow's Main Street occasionally screened movies that were filmed in and around Barstow. Scenes for Gene Autry's 1935 *Tumbling Tumbleweeds* were among the local movie projects. Also pictured is the Village Hotel, a popular Los Angeles–to–Las Vegas stopover for travelers and celebrities. (Courtesy of the Mojave River Valley Museum.)

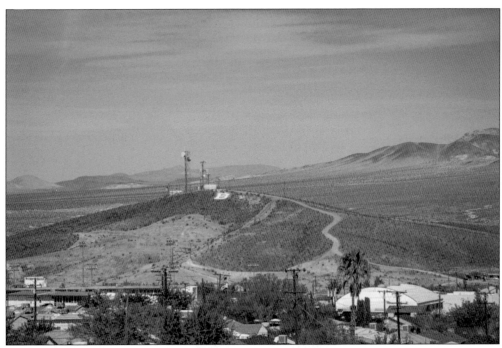

The iconic B Hill is the summit of Old Town Barstow. From this center point, B Hill overlooks Barstow High School while providing a panoramic view of Main Street, the Burlington Northern Santa Fe rail yard, and the Harvey House. (Courtesy of the Atkinson collection.)

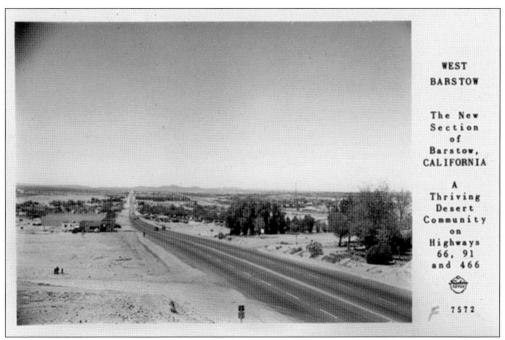

WEST
BARSTOW

The New
Section
of
Barstow,
CALIFORNIA

A
Thriving
Desert
Community
on
Highways
66, 91
and 466

7572

As celebrated in this 1950s postcard, Barstow expanded and became a place where the old roads crossing the southwestern United States from the east came together, crossed and connected with one another, then headed out in important directions. These roads included Route 66, Route 58, Route 91, Route 395, and finally Route 466. (Courtesy of the Mojave River Valley Museum.)

Descending the hill from the west into downtown, bright lights and bumper-to-bumper traffic in this July 1960 photograph illustrate the vitality of Barstow's Main Street. The new freeway, nearby Highway 40, opened soon after and circumvented this popular section of Route 66. The face of Barstow's downtown began to change then, as many businesses lost up to 90 percent of their sales volume. (Courtesy of the Gibson Collection, Mojave River Valley Museum.)

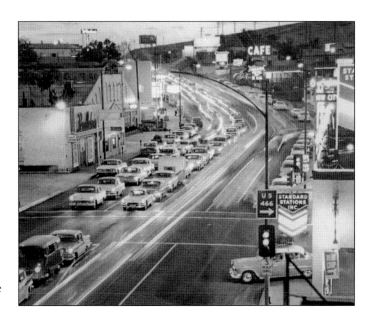

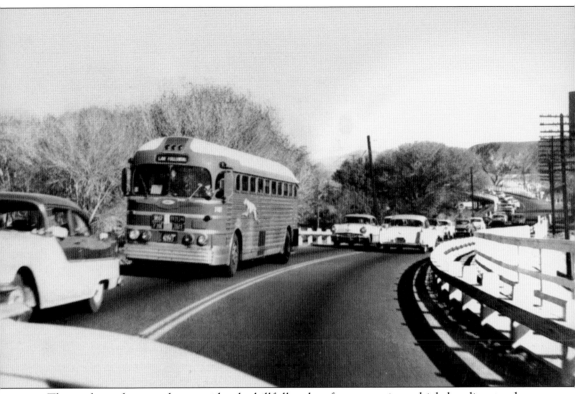

This striking photograph was evidently skillfully taken from a moving vehicle heading northeast on Highway 40 out of Barstow. Traffic from Las Vegas and points east through the 1950s had to cross two bridges to get into Barstow. The first bridge took drivers over the Mojave River, which runs behind the trees at the back of the image, and the bridge in the foreground brought them over the broad expanse of railroad tracks and depot. They would pass by the grand Harvey House buildings in between the bridges down to the left. The traffic lineup includes a Greyhound bus filled with travelers and an endless string of passenger vehicles good for business in a growing, thriving town. (Courtesy of the Mojave River Valley Museum.)

Two

MILITARY

Since the 1700s, military excursions into the Mojave Desert area and the subsequent establishment of camps, forts, and bases have been responsible for much of Barstow's beginnings and growth.

An unusual early excursion was the US military's experiment in the 1850s with using camels in the Mojave Desert. The secretary of war wanted to test the use of camels as transportation for military supplies as opposed to using horses and mules. According to California's state historian, they passed through and surprised many Mojave Desert communities, leaving behind stories that grew mythological. The military use of camels never materialized, and released camels wandered the Mojave Desert for decades.

Pres. Franklin Roosevelt established a Mojave Anti-Aircraft Range near Barstow in 1940. Later, in 1942, the range was renamed Camp Irwin. The compound finally came to be named Fort Irwin. It is located south of Death Valley, Area 51, and the Nevada Nuclear Test Site.

The Marine Corps Logistics Base, one of Barstow's primary employers, began operation in 1942. Its mission as a supply and maintenance installation is to rebuild and repair combat-support equipment. The base's mission has grown to several thousand acres east of Barstow.

The Barstow site for the Goldstone Deep Space Communications Complex was chosen by NASA for a tracking station because it is remote from power lines and free from transmission interference. The Pioneer station was the first deep-space antenna. Constructed in 1958, it became the prototype for the Deep Space Network. It went on to track NASA missions, including Pioneer, Echo, Ranger, the lunar orbiter, Surveyor, Mariner, Apollo, Viking, and Voyager.

These military operations have required myriad workers for the large self-sufficient complexes that would house and train thousands of servicemen over the years. Otto Toppenberg, the author's father, was typical of those who migrated from the Midwest to Barstow in 1949 and found civilian employment at Fort Irwin and around a growing Barstow.

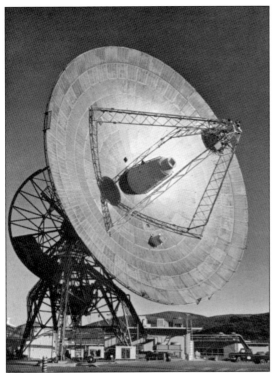

Goldstone, north of Barstow, was the first site chosen for a deep-space tracking station. The location was selected because it is far from power lines and free of interference from commercial radio and television transmitters. Construction began in 1958 on the Goldstone facility's first antenna. The original Deep Space Tracking Station (DSS-11) tracked the first Pioneer probes to the moon. The DSS-11 mission was discontinued in 1981 and declared a national historical monument. DSS-14 was constructed in the early 1960s, and its first signal was from the *Mariner 4* spacecraft. That antenna came to be known as the Mars Antenna and its location as the Mars Site at Goldstone. (Both, courtesy of Goldstone Deep Space Communications Complex, National Aeronautics and Space Administration.)

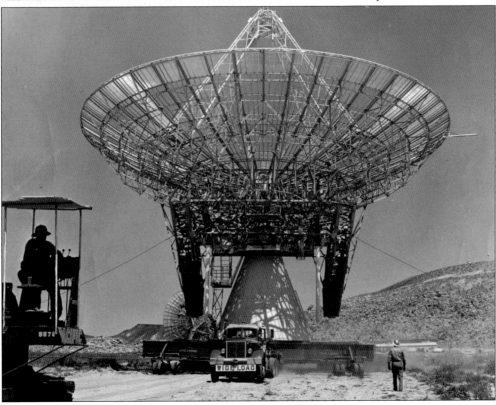

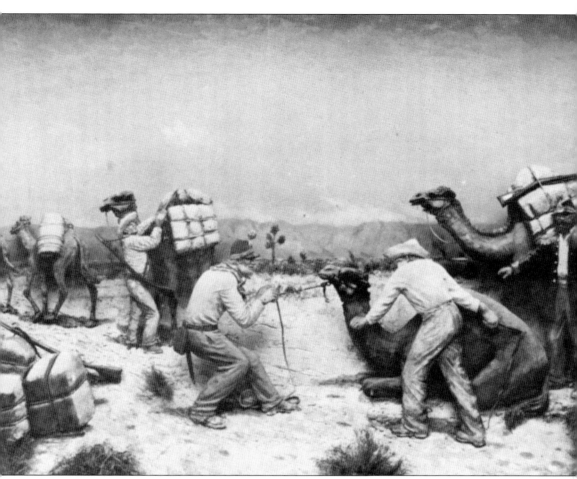

The Camel Express is an 1857 Carl Rakeman painting of the infamous military experiment to determine if camels would be a better choice for hauling supplies in the hot, dry Mojave Desert. Camels were purchased in the Middle Eastern desert and shipped to a seaport in Texas. A Greek named Hadji Ali, whose name became Hi Jolly, was hired as a camel driver with Lt. Edward Beale. When the camel experiment disintegrated, Hi Jolly changed his occupation to gold prospecting and camel hunting. (Courtesy of the California State Library.)

Edward Fitzgerald Beale led several historic expeditions across the Mojave Desert. In 1856, he was sent out to build a road, parallel to present-day Highway 40 between Barstow and Needles, and take imported camels along to determine their suitability for transport of goods for the military. (Courtesy of the California State Library.)

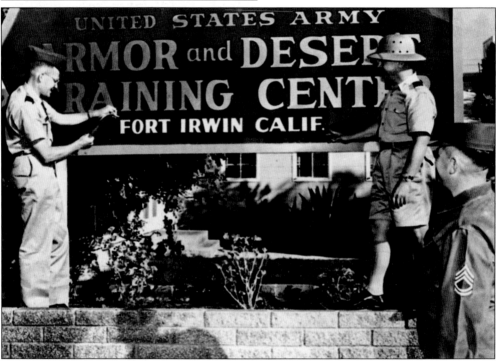

The site of today's Fort Irwin just east of Barstow has had several incarnations in its history. In 1940, it was founded as the Mojave Anti-Aircraft Range. In the 1950s, the California Mechanized Infantry started using the post as its training center. In 1959, the post became the US Army Armor and Desert Training Center, pictured here. (Courtesy of the National Training Center and 11th Armored Cavalry Regiment Museum.)

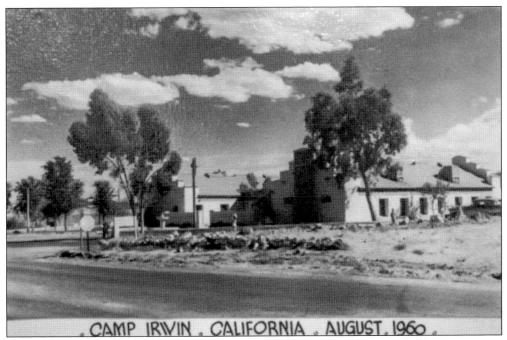

. CAMP IRWIN . CALIFORNIA . AUGUST 1960 .

After being temporarily decommissioned, Camp Irwin was reactivated in 1951 as an armored-combat training area and served as a training center for combat units during the Korean War. The post was designated a permanent installation in 1961 and renamed Fort Irwin. During the Vietnam buildup, units such as artillery and engineering trained and deployed from Fort Irwin. (Courtesy of Fort Irwin National Training Center.)

Richard A. Griffith was Barstow's first Gold Star recipient. He poses on the left in this 1913 photograph with his brother-in-law Harvey Schmitt. Griffith lost his life in France in September 1918. Both were employees of Santa Fe Railway. The Barstow Depot was a major rail destination and crossroads for troops during both world wars. (Courtesy of the Mojave Valley River Museum.)

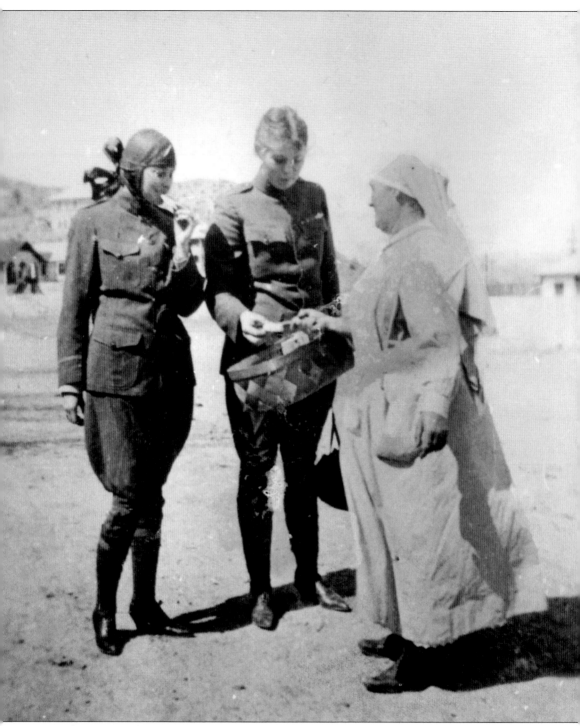

Pauline Carter of Barstow, at left in aviator uniform, is pictured here in 1918 with two other women who have taken on new duties in a time of war. Women from Barstow joined other women in service to the country, nursing, and manufacturing, but they also learned to pilot transportation and mail-delivery aircraft. (Courtesy of the Mojave Valley River Museum.)

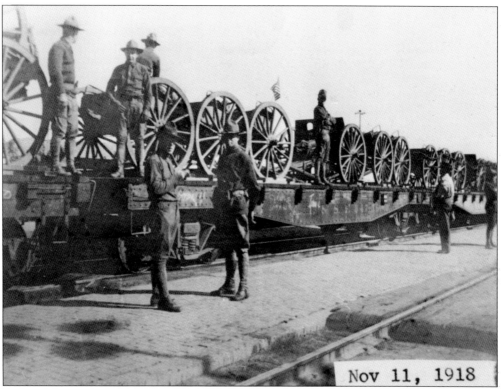

Nov 11, 1918

Railroad flatcars loaded with armaments passed through the Barstow rail yards during both world wars. This 1918 photograph shows troops readying a full load for transport to shipyards on their way to the front in Europe. Barstow's depot, citizenry, and businesses all volunteered their goods and services and also benefited economically. (Courtesy of the Mojave Valley River Museum.)

US Army training camps were created on several dry lakebeds near Barstow. This 1940s photograph shows one of Gen. George S. Patton's tent cities. The Mojave Desert provided vast open space for combat troops to train and practice maneuvers they would employ on desert battlefronts overseas. (Courtesy of the Mojave Valley River Museum.)

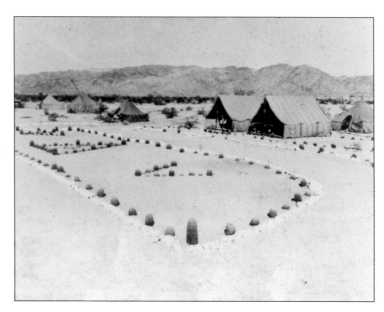

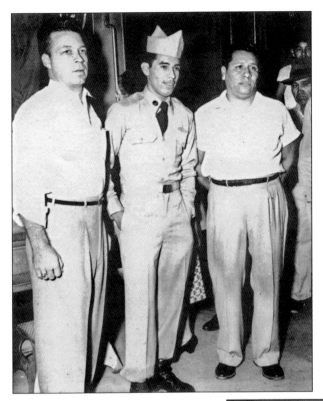

Here are three of Barstow's armed services veterans who returned home after being held as prisoners of war. Pictured are, from left to right, Earl DeWolf (US Army Air Corps, Germany), John Salazar (US Air Force, Corregidor Island, Philippines), and David Villifana (US Army, South Korea).
They are being honored by the Richard A. Griffith American Legion Post. (Courtesy of the Mojave Valley River Museum.)

Tris Hubbard, shown here in military uniform, was a 1947 graduate of Barstow High School. Prior to his service, he played football as a tight end and was known to "catch passes and how." He and other young Barstow men joined the various branches of the armed services in droves to help their country win World War II. (Courtesy of the Mojave River Valley Museum.)

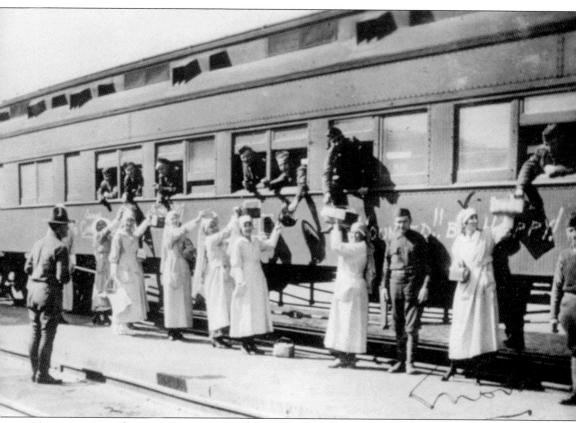

A troop train with a passenger car full of World War I soldiers has stopped at the Barstow Harvey House. They are receiving box lunches from women volunteers of the Red Cross. Barstow was a pivotal point in moving military trainees to and from Camp Irwin. The training center is located 35 miles northeast of Barstow. (Courtesy of the Mojave River Valley Museum.)

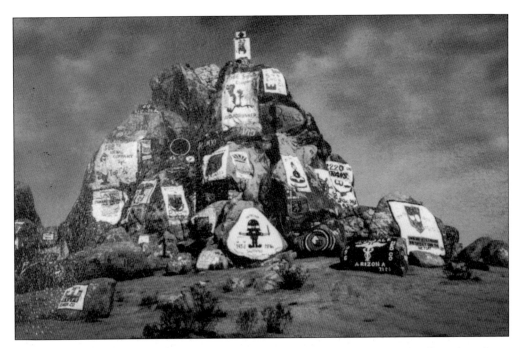

Since Fort Irwin became a major training center for the armed forces, hundreds of battalions have traveled from around the country to train here. Since 1958, each group has painted a large rock at the entrance to the base as a remembrance of its experience on the Mojave Desert. The rock memorial has expanded into a major art piece at the entrance to the base. (Above, courtesy of Fort Irwin National Training Center; below, courtesy of the Atkinson collection.)

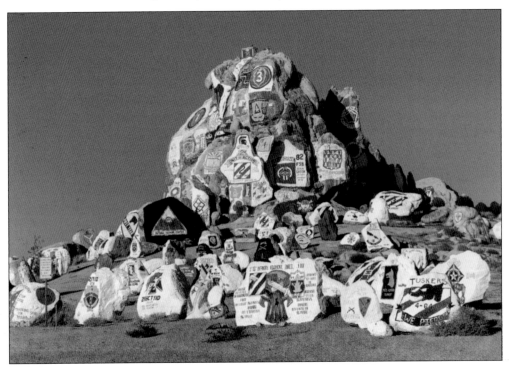

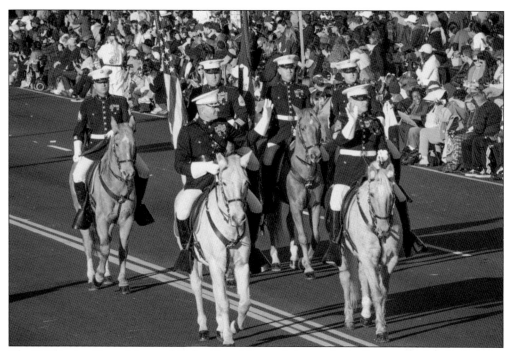

The US Marine Corps Mounted Color Guard first rode in parades in Barstow, Calico, Ridgecrest, and Yermo rodeos during the 1950s and 1960s. As its reputation grew, the group appeared around the country and was the first military unit to lead the Tournament of Roses parade. The guard is garrisoned at the Marine Corps Logistics Base in Barstow, and rides palomino mustangs adopted through the Bureau of Land Management. (Photograph by Ramona Monteros.)

The Marine Corps Depot of Supplies was established near Barstow in 1942 as a storage site for supplies and equipment needed for World War II. With very little entertainment around their isolated desert location, the men formed their own swing band, pictured here. (Courtesy of the Mojave River Valley Museum.)

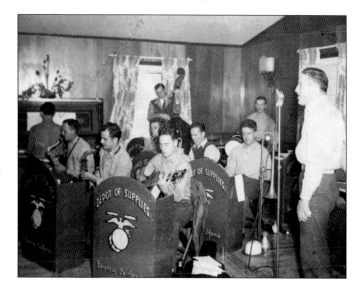

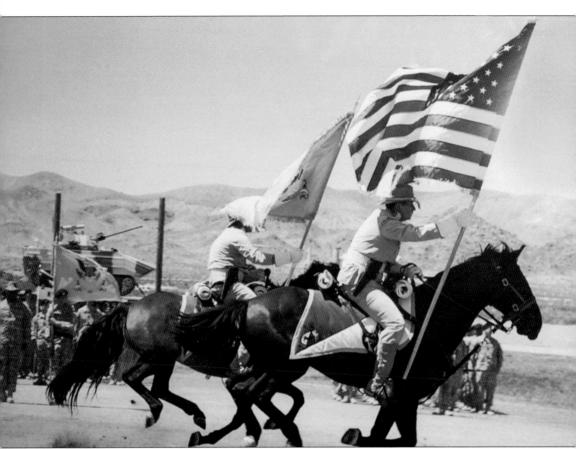

In 1901, the 11th Cavalry was one of five new regular Army regiments formed after the Spanish-American War. Historically referred to as "Ironhorse," the regiment was reflagged 1st Squadron, 11th Armored Cavalry Regiment with the mission of opposing forces for the national training center. The regiment came to be called "Blackhorse" while stationed at the Presidio of Monterey. Today, the regiment and the mounted unit are garrisoned at Fort Irwin outside of Barstow, California. (Courtesy of National Training Center 11th Armored Cavalry Regiment Museum.)

Three

RAILROAD AND
THE HARVEY HOUSE

Barstow's railroad heritage began before the first tracks were laid through the Mojave Desert. The faint trails sketched by the moccasins of early native travelers were discovered and followed along the Mojave River. Explorers on horseback and immigrants in wagons followed along the trails, soon to be called the Mojave Trail and the Old Spanish Trail. Finally, visionary adventurers and entrepreneurs gambled and won when they laid the first railroads across the desert. Trains became the favored means of travel and delivery of goods across the western United States for decades before automobiles arrived, and Barstow became the primary locus for the first rail lines across the Southwest.

The town of Barstow began as a few buildings dotted around a rail yard and depot. Barstow's first businesses opened at the rail yard. Fred Harvey built one of his famous Harvey Houses there, giving the town a sophisticated ambience. Trains stopped in Barstow for passengers to alight for meals and cargo transfers.

During World War I, soldiers used the rails to get to and from training camps and their wartime deployments. They too enjoyed the stops in Barstow and were royally treated by the Harvey Girls to the excellent fare served there. As there were two major military installations in the area, thousands of troops rode into and out of Barstow in those busy times.

A variety of people came to Barstow for employment. Fred Harvey's establishment became a favored location for young women to find proper and protected employment. They received high-class training in food service and followed a strict code of behavior when they lived and worked at a Harvey House. Native Spanish American people rode the rails into Barstow from New Mexico, and African Americans came from the southeastern United States to become part of the large crews building, repairing, and servicing the trains and rail yard facilities.

Eventually, the popularity of rail travel gave way to the advent of automobiles and new construction of cross-country highways. The Harvey House closed in the 1970s, and other businesses had already moved across the new bridge to become part of the growing city of Barstow.

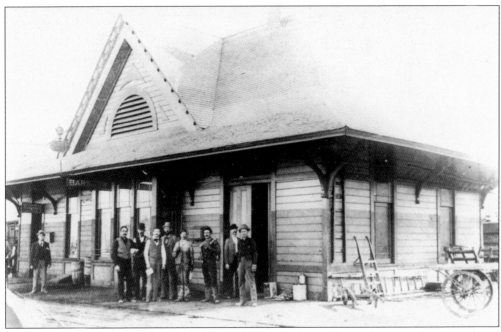

This 1800s photograph depicts the original Barstow Railroad Depot. It was built of wood and burned to the ground in 1887. The replacement burned a few years later. The third incarnation was the first Harvey House, built in 1905, but in 1908 it too burned. (Courtesy of the Mojave River Valley Museum.)

This roundhouse operating crew at the Barstow rail yard takes a break for a 1903 photograph. The roundhouse, located to the southeast of the Harvey House, was a device for turning locomotives around so that they could travel back in another direction. In 1939, it burned down, leading to the construction of the Barstow Diesel Shop in 1947. (Courtesy of the Mojave River Valley Museum.)

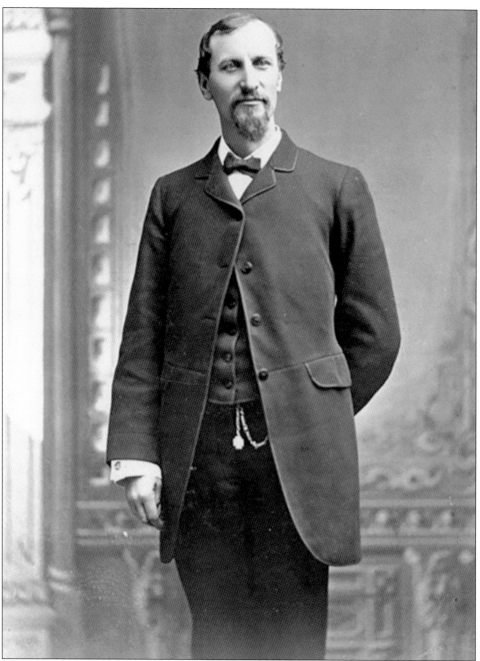

Rail travel was the transportation of choice from the late 1800s to the 1930s. Trains pulled no dining cars at that time, so visionary Fred Harvey developed a string of dining rooms with boardinghouses for passengers at depots along the Santa Fe Railway line. In 1911, he designed and built the Barstow Harvey House, named Casa del Desierto, at the cost of nearly $1 million. It became known as one of the jewels of his operation. He initiated a management system that included first-class fare served by well-trained hostesses who became known as Harvey Girls. The main building of the Barstow Harvey House has been restored and remains the jewel of the rail yards. (Courtesy of the Barstow Harvey House and Rail Depot.)

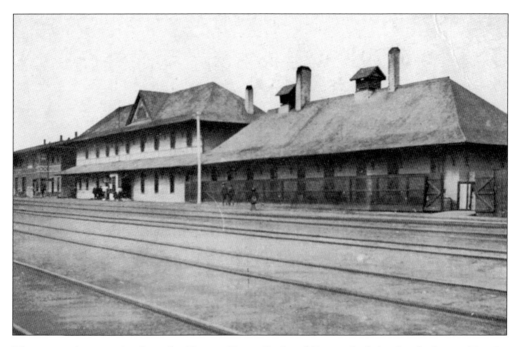

These two photographs show the Harvey House Railroad Depot, built by the Atchison, Topeka & Santa Fe in the late 1800s. The structure was rebuilt three times after unfortunate fires. Fred Harvey designed and furnished the hospitality buildings, installed the kitchen equipment, and hired the staff. After the last fire in 1908, the fourth reincarnation, Casa Del Desierto (translated as House of the Desert) was built in 1911 to be fireproof. (Both, courtesy of the Mojave River Valley Museum.)

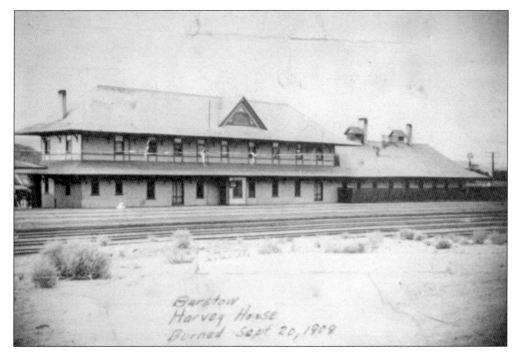

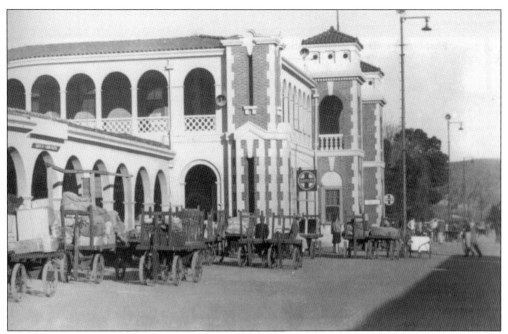

The railroad depot and Harvey House were the center of Barstow's commerce in the late 19th and early 20th centuries. This complex encompassed three buildings all connected by graceful covered walkways and shaded by verandas. The Santa Fe workman's dormitory called the Reading Room included a recreation hall and medical offices. (Courtesy of the Mojave River Valley Museum.)

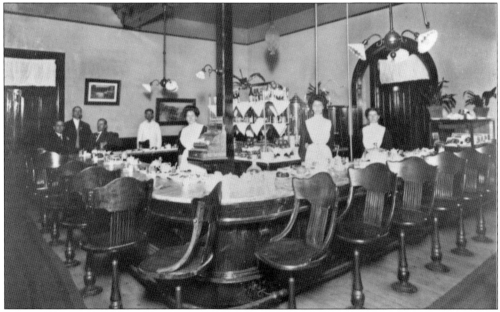

Pictured here is the lunchroom at the Barstow Harvey House in its heyday. Since there were no eating facilities on trains in those days, Harvey Houses all along major rail routes awaited railroad passengers who were looking forward to excellent fare and gracious service. The Barstow Casa del Desierto was one of the most luxurious and has been fully restored. (Courtesy of the Mojave River Valley Museum.)

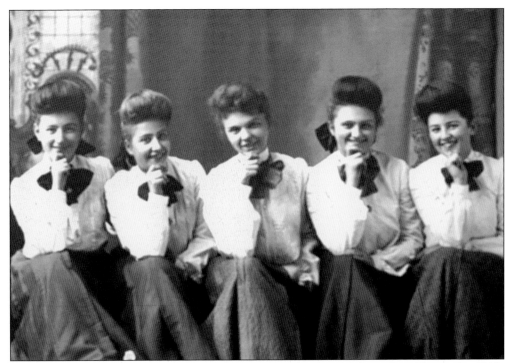

Young women looking for work and adventure during the decades from the 1850s to the 1940s traveled to the West to one of Fred Harvey's new railroad depot restaurants along the Santa Fe Railway. They joined the ranks of Harvey Girls as waitresses and hostesses and followed strict rules of grooming and behavior while they lived in a Harvey House. (Courtesy of the Barstow Harvey House and Rail Depot.)

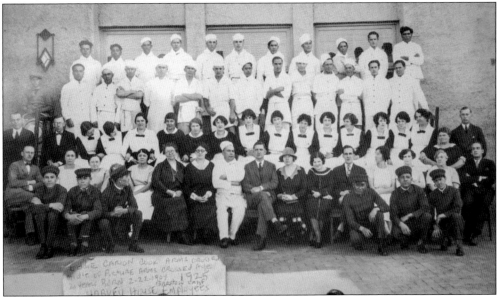

During the 1920s, there were more than 60 employees at Casa Del Desierto Harvey House in Barstow. The fellow seated front and center is the cook, surrounded by managers, servers, runners, kitchen helpers, and hostesses. (Courtesy of the Barstow Route 66 Museum.)

Women were able to acquire a valuable trade by becoming Harvey Girls. They learned speaking skills, etiquette, grooming, and general carriage through their training for the job. This young Barstow lady models the full Harvey Girl uniform, which signifies qualification to work in the formal dining room. (Courtesy of the Mojave River Valley Museum.)

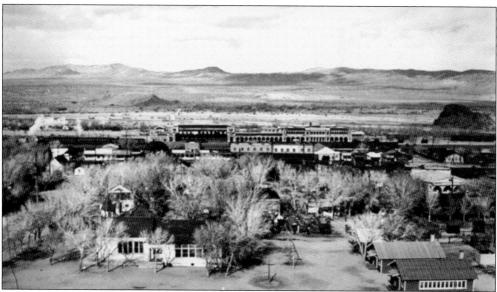

The architecturally splendid Santa Fe dormitory, Harvey House, depot, and hotel are seen in this 1940s photograph. The new bridge leads over the tracks toward a new Barstow town center, and there are new workforce apartments in the lower left of the photograph. The quality of the facilities in this scene reflects the vitality and importance of the Barstow rail center during this time. (Courtesy of the Mojave River Valley Museum.)

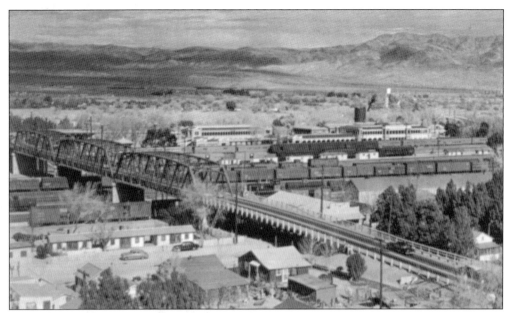

This is an excellent 1950s view of the Barstow Rail Yard. The Harvey House depot, hotel, and dormitory are pictured here with a passenger train waiting on the tracks. Vast open areas of the Mojave Desert fill the background, and rail workers' apartments and homes are in the foreground. The First Street Bridge over the tracks ties the scene together. (Courtesy of the Mojave River Valley Museum.)

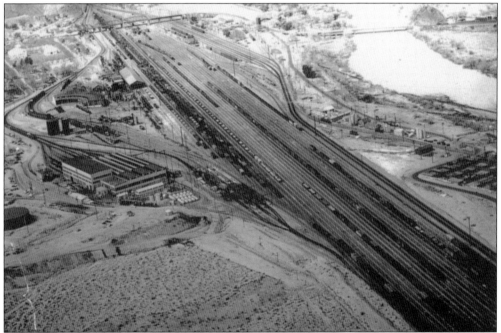

By 1950, the Santa Fe Railway became part of the largest rail complex in southwestern California. The new Harvey House sits at the top of the photograph in the curve of the bridge. The First Street Bridge crosses the tracks near Central High School on the left. (Courtesy of the Mojave River Valley Museum.)

Delores Rocha (left) and coauthor Donald Atkinson's grandmother-in-law, Sinty Pearl Grigsby—railroad workers at the Atchison, Topeka & Santa Fe Railway yard—take a well-deserved break in this rare World War II–era photograph. More than six million women, including many of Hispanic and African American descent, filled government, industrial, and commercial positions during that war. (Courtesy of the Jefferson Collection, Mojave River Valley Museum.)

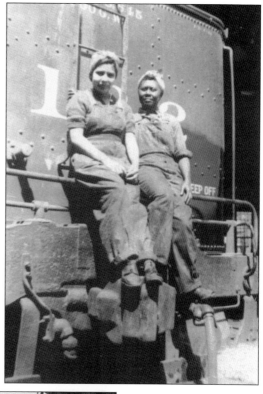

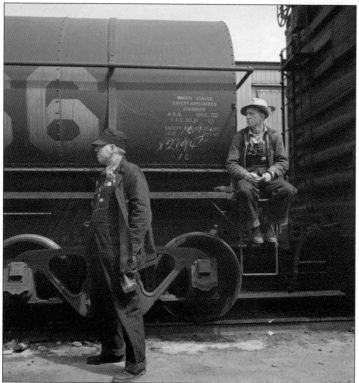

Brakeman J.C. Shannon and swing brakeman B.F. Wilson prepare for their train to pull out of the Barstow Atchison, Topeka & Santa Fe rail yard in this 1943 Jack Delano photograph. Workers came from all points around the country for the myriad job opportunities afforded by the expanding rail lines and service depot facilities. (Courtesy of the Library of Congress.)

Railroad employees often spent many days away from home and family. Pictured here in this 1943 Jack Delano image are brakeman Charles Dawes and coworkers registering for a stay in dormitories provided by the AT&SF Railway. Santa Fe ran special trains from New Mexico to bring Native Americans to Barstow to work. (Courtesy of the Library of Congress.)

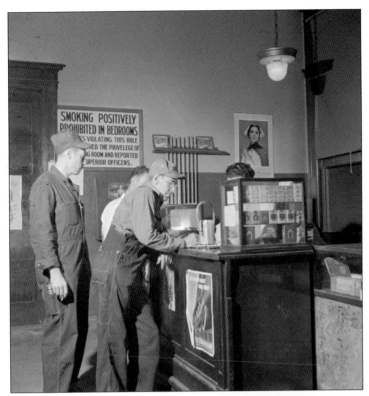

This 1943 Jack Delano photograph depicts the Harvey House Reading Room converted into sleeping quarters during busy times at the AT&SF rail yards in Barstow. Brakeman Thurston H. Lee of Chicago prepares for his rest after a long, hard workday. (Courtesy of the Library of Congress.)

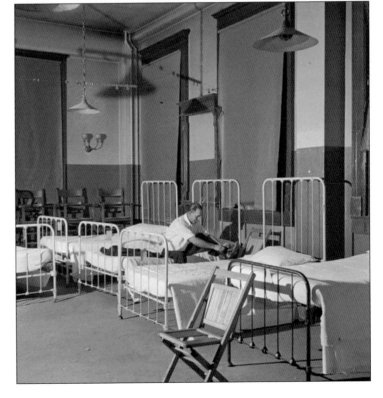

Harvey Girls at the Harvey House lunch counter, shown here in this 1943 Jack Delano photograph of the restaurant, served thousands of servicemen, rail yard workers, travelers, and Barstow residents during its 40 years of service in the 1900s. Founder Fred Harvey created protocols for serving excellent fare. For example, he was known to have analyzed the water at each of his restaurant locations and created the best possible coffee formulations for each. (Courtesy of the Library of Congress.)

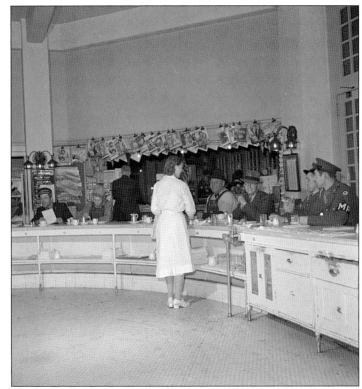

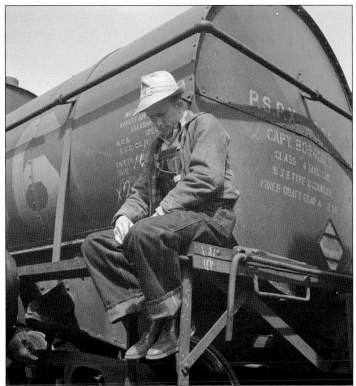

AT&SF Railroad swing brakeman B.F. Wilson sits patiently on a tank car waiting for his train to leave. Photographer Jack Delano captured this image at the Barstow rail yard in 1943. (Courtesy of the Library of Congress.)

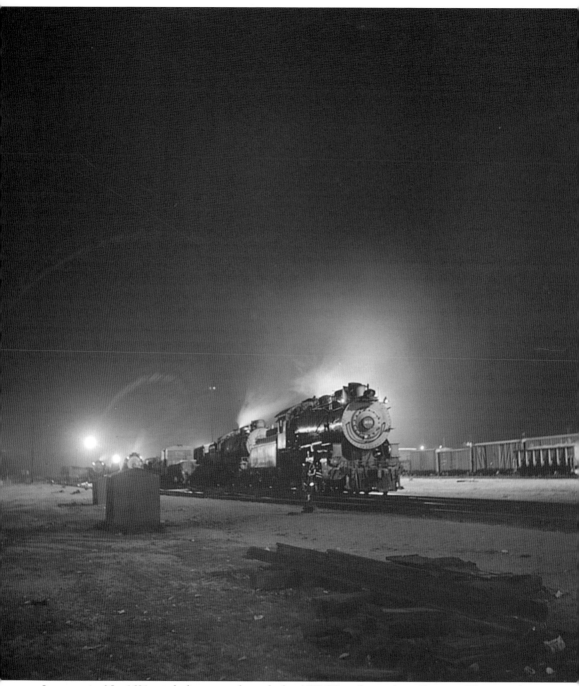

Locomotive No. 1691 regularly steams through the AT&SF yard at night in Barstow. Photographer Jack Delano, well known for his topical photographs, took this striking image in 1943. Rail yard employees worked long hours through days and nights to ensure that the trains operated well and on time. (Courtesy of Library of Congress.)

This vintage photograph of the original Second Street footbridge includes a perspective view of the rail yard with the original Harvey House and depot buildings near the left end of the bridge. In 1930, two stronger bridges—one crossing the Mojave River and one crossing the wide expanse of tracks—were built. (Courtesy of the Mojave River Valley Museum.)

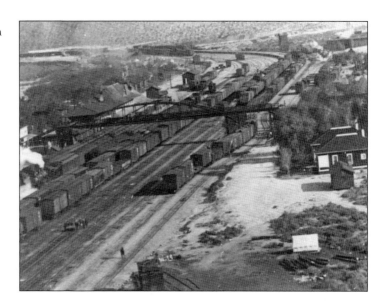

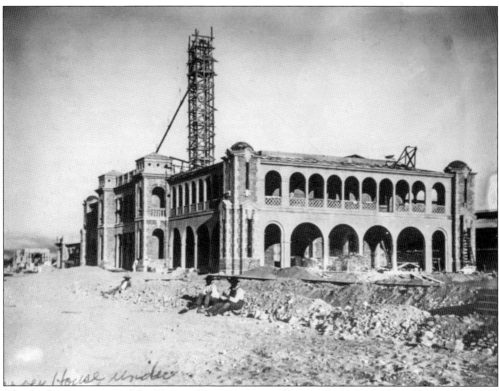

The final incarnation of the Harvey House is pictured here rising above the rubble and landfill that cover the earlier building. It was designed by architect Francis William Wilson in a takeoff on Spanish and Moroccan styles. This was a lovely contrast to the traditional buildings of Old Barstow. (Courtesy of the Steiner Collection, Mojave River Valley Museum.)

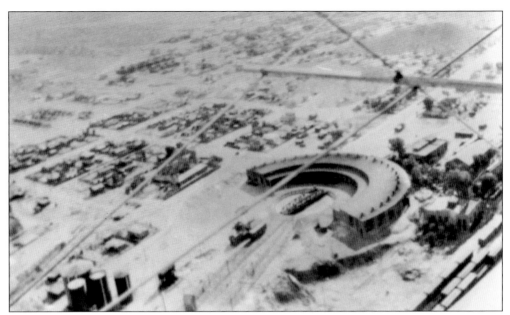

This is an aerial photograph of the roundhouse at the Barstow Rail Yard from around 1945. Locomotives were guided onto a turntable so they could move forward in another direction. If they needed repair, they were moved into a stall in the roundhouse. (Courtesy of the Western America Railroad Museum.)

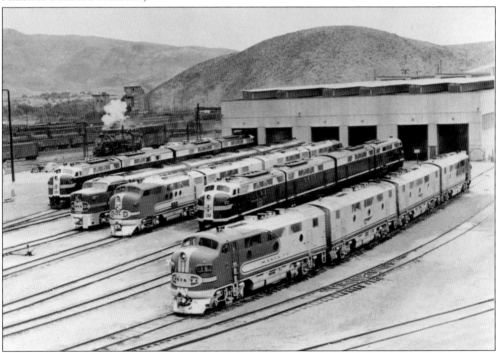

Locomotives are arrayed around the diesel repair shop at the Barstow rail yards. The one in the foreground is a good representative of the Santa Fe Super Chiefs, which began their 35-year reign on the rails in 1937. The scene is shadowed by one of the large, domed hills common in the Mojave Desert around Barstow. (Courtesy of the Western America Railroad Museum.)

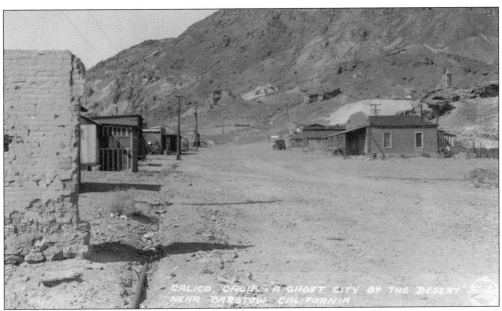

Calico, California, established in 1881, was the center of California's silver-mining era, which reported extractions of more than $20 million. There were more than 500 mines and 1,200 people between 1883 and 1885, and the population grew to 3,500 by 1890. When the 1890 Silver Purchase Act drove down the price of silver, Calico became a ghost town. (Courtesy of the Mojave River Valley Museum.)

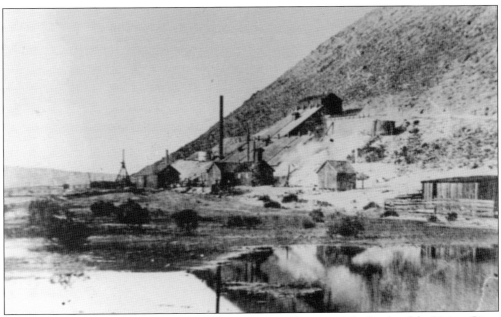

Shown in this 1880s vintage photograph, the Grapevine District on the banks of the Mojave River in Daggett, California, included two large silver stamp mills, the Oriental and the Waterloo. A narrow-gauge railroad ran from the mills to the Josephine, Red Jacket, and Silver King Mines six miles north near Calico. Mule teams had provided ore transport before the railroads were built. (Courtesy of the Mojave River Valley Museum.)

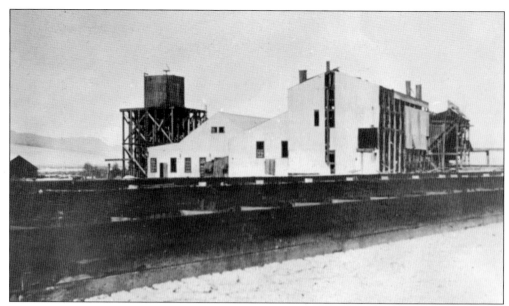

The American Borax Company constructed the Columbia Mine Railroad in 1900, connecting the Calico Mountain mine to the Daggett plant east of Barstow. The line soon merged with the Waterloo Mine railroad. The US Boron Borax Mine, California's largest open-pit mine and the largest borax mine in the world, still operates today. (Courtesy of the Alf Collection, Mojave River Valley Museum.)

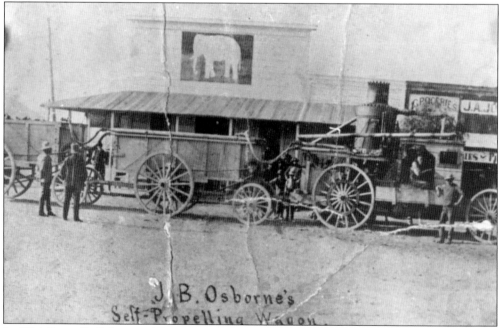

In 1914, Jonas B. Osborne of Daggett, California, used this self-propelling wagon, called "Old Dinah," well ahead of its time. Early steam tractors like these proved too heavy for use in the desert, where sand drifts would sink the iron and wood wheels. Farmers returned to their horses, oxen, and mules to pull, plow, and haul until well into the next decade. (Courtesy of the Alf Collection, Mojave River Valley Museum.)

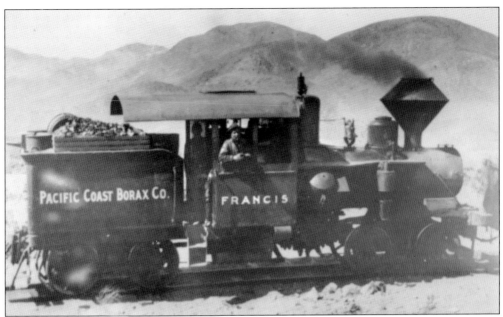

Narrow-gauge railways were built during the height of the silver- and borate-mining boom in the late 1800s. Replacing the 20-mule teams and running on the small three-foot-wide rails were locomotives hauling payloads of silver ore out of the mountains east of Barstow. The narrow-gauge engine pictured above hauled borate for the American and the Pacific Coast Borax Companies. The locomotive in the photograph below was part of the Waterloo Mining Railroad. This engine carried silver ore for the Oro Grande Mining Company's mines in the Calico Mountains to processing plants at Elephant Mountain in Daggett, California. (Both, courtesy of the Western America Railroad Museum.)

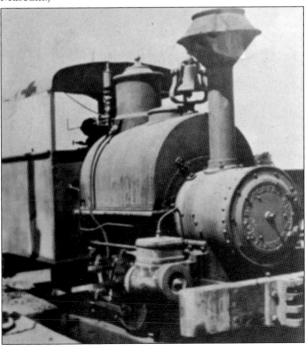

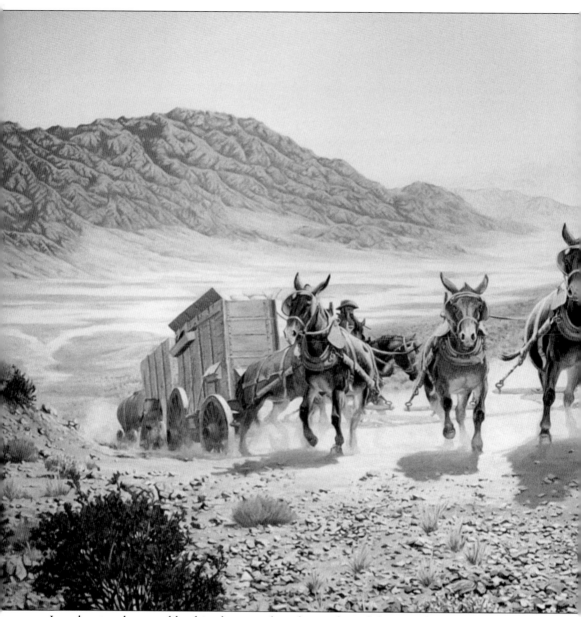

In order to make turns like this when traveling the rough roads between borate mines in Calico and borax facilities near Barstow, mules had to be trained to step over the traces of the harness and pull the string outward in sequence into the full arc of the turn. Artist Dan Turner painted this unique 1930s scene, *Dance of the Mules*. The experienced men who handled and drove the

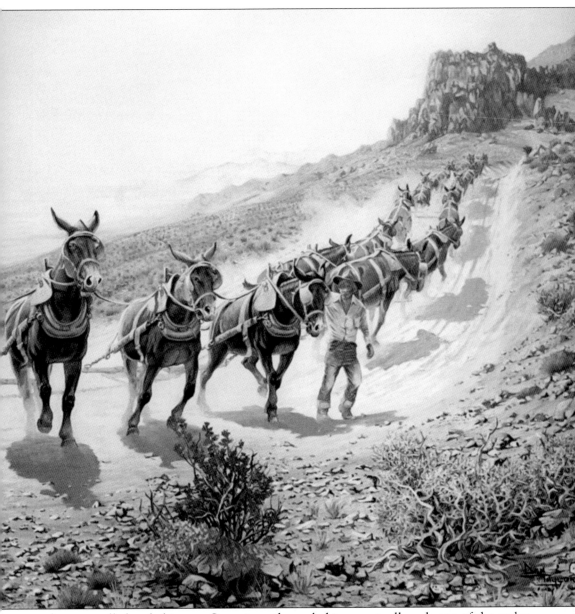

mules were called muleskinners. Sometimes the muleskinner actually rode one of the mules and guided the entire team with a single rein called a jerk line. (Courtesy of the Mojave River Valley Museum.)

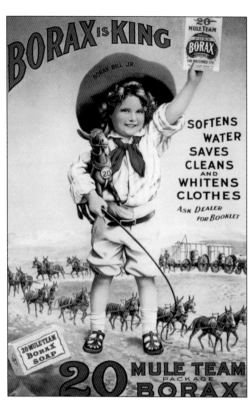

This 1905 advertising poster illustrates two of the original Borax products, borax bar soap and borax laundry powder. When the railroads took over product transport, the 20-mule team began a new career in 1891—promoting the borax such teams used to haul. Through the popular television series *Death Valley Days*, the ads made nearby Death Valley and 20 Mule Team products famous throughout the world. (Courtesy of the Boron Twenty Mule Team Museum.)

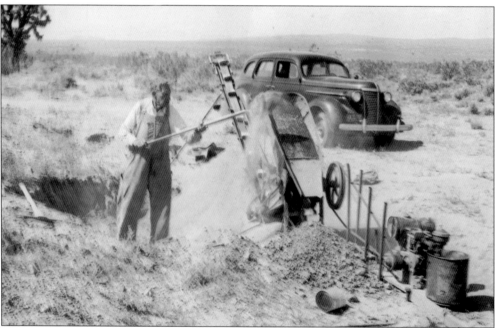

A lone prospector named Dodson searches for gold in Superior Valley north of Barstow in this 1947 photograph. Dodson is using the dry-washing method, which uses no water to shake and separate gold dust from dirt. He has employed a 1937 Nash Lafayette automobile as his desert transport. (Courtesy of the Mojave River Valley Museum.)

Five

PEOPLE OF BARSTOW

Pres. Teddy Roosevelt told the people of Barstow in 1903 that he was proud of the essential unity of all Americans and congratulated them on what they had accomplished in the middle of the southwestern California desert.

The early Americans gathering up in Barstow became a true melting pot of humanity. There were Native American people already living in the area, and they were joined by explorers, immigrants, settlers, and entrepreneurs from all parts of the country. They followed paths laid down by moccasin feet, trails left by saddle horses and wagons, and eventually new paved roads, most of them leading to places like Barstow.

When native Latino people, predominantly of Indian and Spanish heritage, found little or no work in New Mexico and Arizona in 1943, they headed west on Route 66, settling where the Santa Fe Railway was offering employment: Barstow. Many families came from Belen, New Mexico—so many that the Route 66 Museum opened a special section dedicated to their journey.

To house incoming workers, tents and small houses called victory homes were built by the Santa Fe Railway where the Barstow city offices now are located. Few if any of these tiny dwellings still stand around the area of Seventh Street between Williams Street and the old hospital.

During the 1930s, Barstow folks were able to receive a radio station from Rosarita Beach in Mexico. Western and country music was often heard along with diatribes about health-giving elixirs. One of the lost-in-time songs played back then had lyrics something like this: "I'm a barstool cowboy from old Barstow, and the barroom is my range, my hitching post is the old brass rail, and if I can rustle a drink with your change, I'm home, home on the range."

The people and the culture of Route 66 and Barstow are intertwined. The road brought most of the people who settled there. The road passed through Main Street Barstow during its most formative years, creating a business core centered on travel and entertainment. And thousands of travelers still find Barstow and its people both fascinating and industrious.

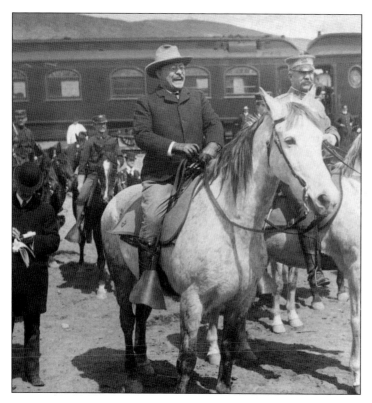

In 1903, Pres. Theodore Roosevelt (foreground) traveled throughout America to promote conservation. This photograph from that 25-state speaking tour shows a smiliing Roosevelt with Maj. John Pitcher (right) and mounted cavalry. On March 7, Roosevelt's route took him through Barstow, where he remarked, "I am speaking here to the men who have done their part in the tremendous development of this country." (Courtesy of the Library of Congress.)

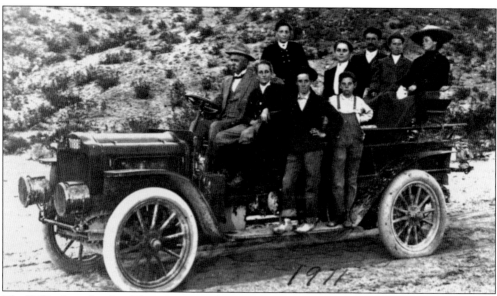

The Dillingham family of Barstow is seen here in this 1900s photograph. Posed around the large automobile, they seem to be preparing for a Sunday driving tour around town. When at work, they built apartments in 1917 and ran a mercantile they acquired in 1900. (Courtesy of the Mojave River Valley Museum.)

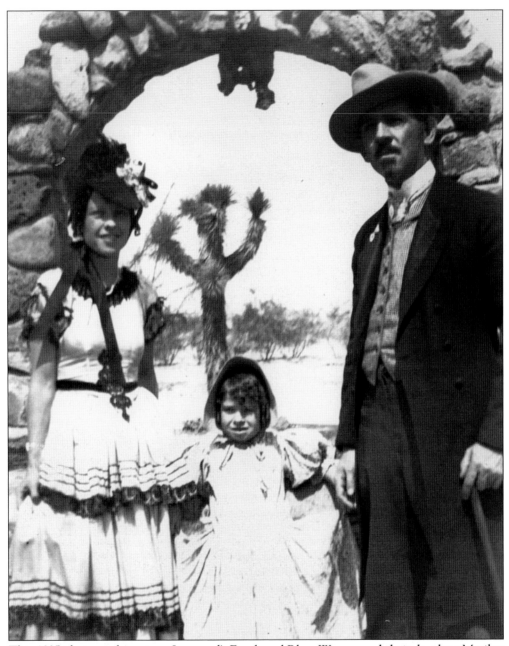

This 1935 photograph portrays Lenwood's Frank and Rhea Wagner and their daughter Marilyn near the stone arch over the well in the luxurious Beacon Hotel's garden. They are fully costumed for Barstow's Calico Days annual celebration. Calico is the famous and once lucrative old silver-mining ghost town just east of Barstow, which contributed grandly to the economic vitality of the community. The event always includes a long and well-attended parade full of floats, horses, and music groups, and the Wagners are ready to celebrate. (Courtesy of the Wagner collection.)

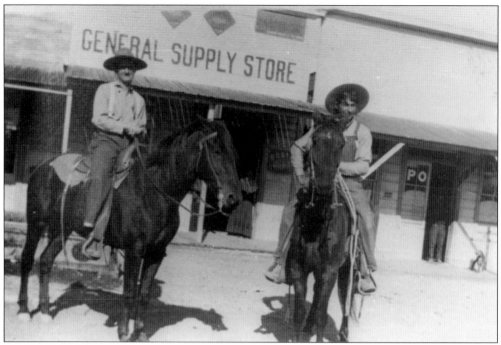

Transportation in the early 1900s was still highly dependent on horses and mules in areas where most roadways were not yet developed enough to accommodate the new automobile. These two farmers above have been successful enough to be riding horses to the Barstow-area general store. Within a few years, the family in the photograph below has graduated to an automobile for their transportation. Horse and buggy continued to be used alongside cars on the rough roads of the early 1900s. (Both, courtesy of the Mojave River Valley Museum.)

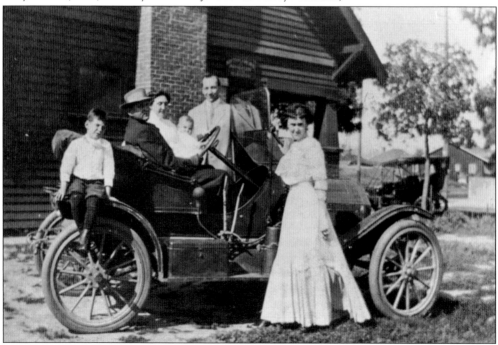

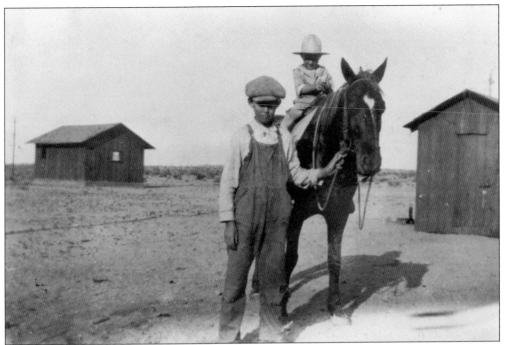

The Rupert brothers in this 1920s photograph are taking a break from their chores to have their image taken with the family horse. The cabin in the left background is typical of the requisite size and simple construction of homestead cabins in the Barstow area. (Courtesy of the Mojave River Valley Museum.)

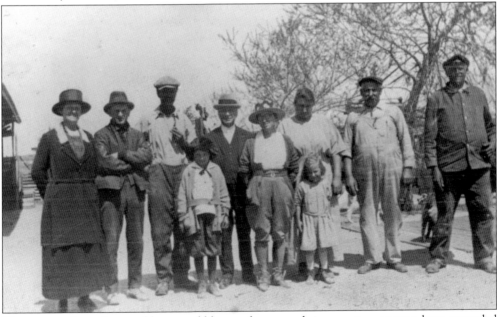

This group of people was able to scrabble together enough income to support a large extended family and one or two hired hands. In the 1800s, farming or service businesses like wagon repair, blacksmithing, or storekeeping were the major income-producing activities until the military and railroads began hiring. (Courtesy of the Mojave River Valley Museum.)

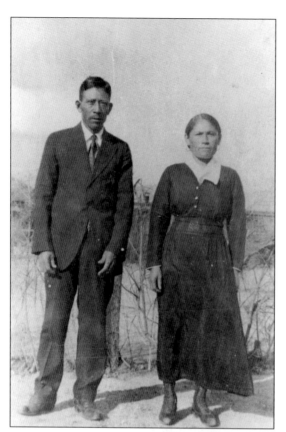

Camillo and Guadalupe Duran emigrated from Mexico to Barstow. This portrait was taken in 1918. The Durans were part of a large influx of Latinos to the area looking for a better life for their families. They had five children born in California. (Courtesy of the Mojave River Valley Museum.)

Students from the Hinkley Grammar School class of 1938 pose for their photograph at the front of the building. Class size swelled in the decades when large numbers of immigrants from Mexico and New Mexico and eastern states moved into the Barstow area for railroad work. (Courtesy of the Mojave River Valley Museum.)

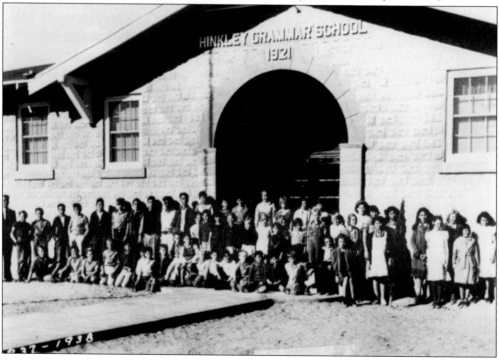

All through the early 1900s, everyone went to the rodeos in Barstow. Action like this was one big reason. Ranchers and cowhands, cowgirls and novice dudes all laid down their entry fees to compete in rough stock events like wild-horse and bull riding, roping calves and steers, and grand entry parades, where anyone on a horse rode around the arena. (Courtesy of the Mojave Valley River Museum.)

In this 1930 newspaper photograph, the Pittsburgh Pirates and team star Honus Wagner play an exhibition game at Calico Dry Lake near Barstow. Athletic teams often traveled to the Mojave Desert for training to avoid crowds of fans and the inclement weather of their hometowns. (Courtesy of the Mojave River Valley Museum.)

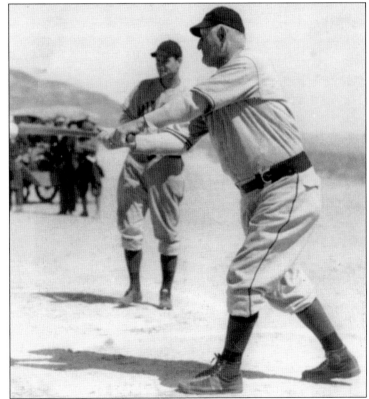

Homesteading was an important way for many people to settle in Barstow. The US government granted free acreages in the dry undeveloped slopes to those who would build and occupy the land. Here, in 1953, the concrete foundation for coauthor Christine Toppenberg's family homestead structure has been laid in preparation for construction. An unobstructed view of the Barstow Mojave River Valley lies in the background. (Courtesy of the Toppenberg family.)

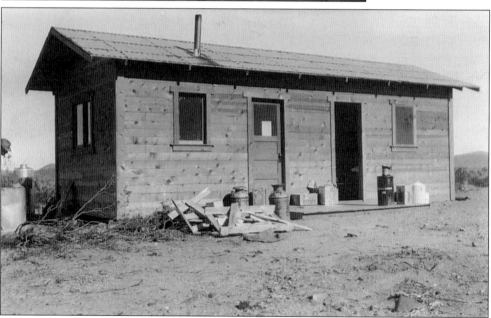

These cabins proliferated in the early 1900s in the completely undeveloped areas around Barstow as homesteaders discovered this way to acquire property. These folks had the gumption to live without water, electricity, indoor plumbing, and graded roads. Note the milk cans and the propane tank at the left. (Courtesy of the Mojave River Valley Museum.)

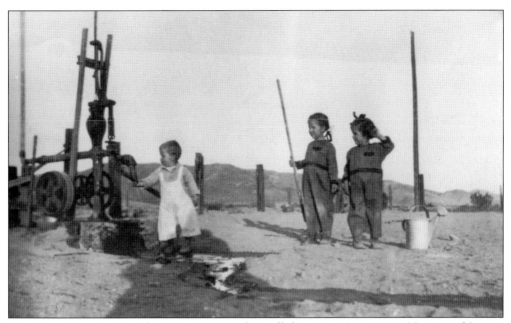

Homesteaders arrived on the Mojave Desert from all directions. Many were Native and Latino Americans from New Mexico. These children pumping and carrying water are typical of the hardscrabble lifestyle on the vast desert where what mattered was one's ability to survive and thrive without easy access to water. (Courtesy of the Mojave River Valley Museum.)

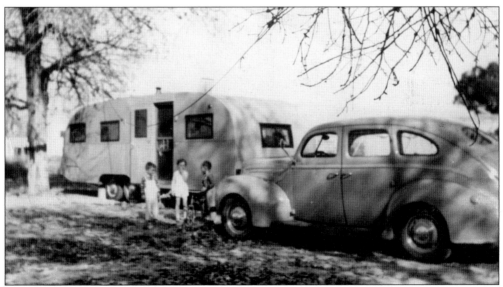

The Teague family arrived at the Barstow Trailer Court on New Year's Eve 1945 from a Michigan winter. The temperature was 84 degrees, and the doors and vents on the automobile are open wide. Pictured here, from left to right, are young Dick Teague, his sister Diane, and a new friend from the court. (Courtesy of the Teague family.)

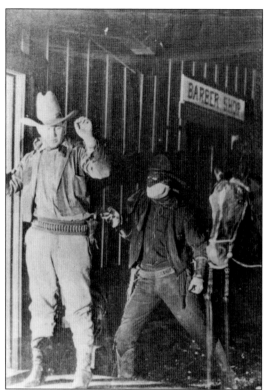

Barstow was an ideal location for Hollywood moviemakers to find authentic sets for their Westerns. This 1940s photograph records a scene in Barstow for an upcoming installment of a favorite movie series. Desert folks, especially local cowboys, were often hired as extras and sometimes had billed roles. (Courtesy of the Mojave River Valley Museum.)

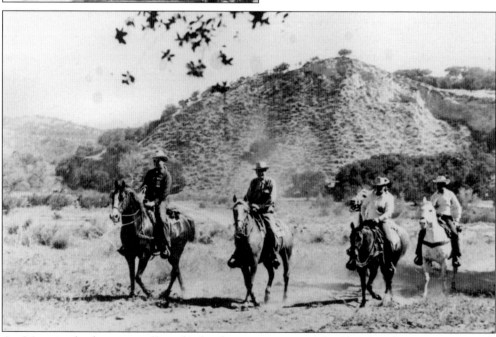

Art Manning leads a group of horseback riders across some of the desert's wide open space. With very little water and few other entertainment venues, owning, raising, training, riding, and showing horses was probably the most popular activity for the majority of people growing up and living in the Mojave Desert. (Courtesy of the Mojave River Valley Museum.)

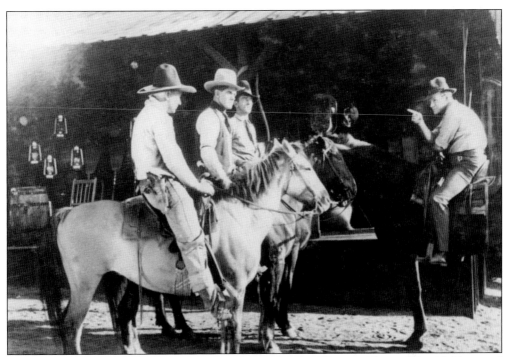

Moviemakers often visited the area. Barstow horseman Art Manning (second from left) started out as an extra and soon made his way into speaking parts in a film or two. Here, he chats with other actors taking a break from a scene where they are using horses hired from local ranches. (Courtesy of the Mojave River Valley Museum.)

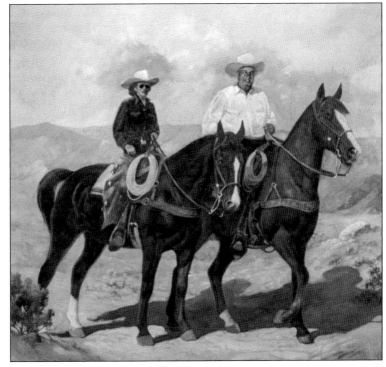

Art Manning (right) is memorialized along with a riding companion in this vintage oil painting. He rode horses most of his life and also while he was sheriff. After a horseback riding accident, he went on to become a justice of the peace in Barstow. (Courtesy of the Mojave River Valley Museum.)

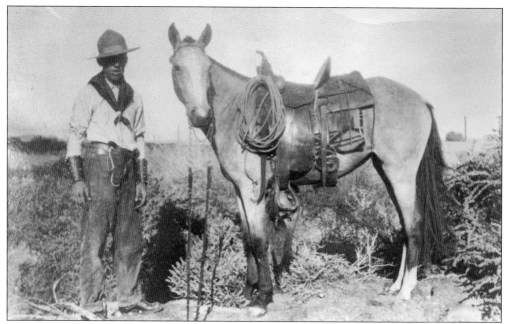

In spite of the normally bone-dry conditions of the Mojave Desert, thousands of beef cattle were raised in summer in grasslands fed by run-off springs and in winter on the sparse bunch grass of the desert flatlands and dry-farmed hay. In this 1940s photograph, a Barstow cowboy shows off his cow horse and gear. (Courtesy of the Mojave River Valley Museum.)

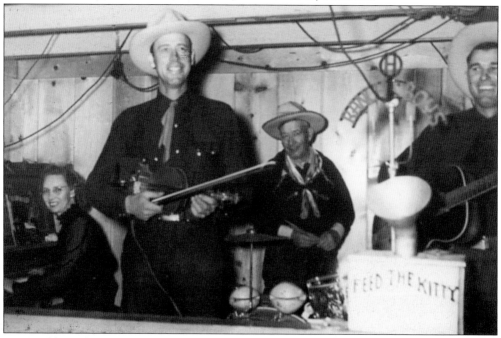

Don Walde's father, known as Pops (with the fiddle), gets ready to play at a Barstow event. Pops and the Circle H Ranch Boys provided entertainment and music for every rodeo club dance in the 1940s and 1950s. The Waldes built and operated the Triangle Trailer Park. (Courtesy of the Walde family.)

Barstow resident Clara C. Dixon was a member of the Arts and Industrial Club of Barstow, serving as president, secretary, and chaplain. She also served 55 years in the Veterans of Foreign Wars auxiliary and the Mojave Valley Citizen's Club. (Courtesy of the Mojave River Valley Museum.)

Young members of St. Joseph Catholic Church appear to be loading up for a field trip in this 1950s photograph. The building in the background, near downtown Barstow, served parishioners for decades before the church built and moved into a new complex farther up the slopes above downtown. (Courtesy of the Mojave River Valley Museum.)

Native Americans often had to adapt to the settlers' town lifestyles. These Paiute women are visiting Brown's Store in Shoshone, a village northeast of the Barstow area often denoted as a gateway to Death Valley. Jobs were few in these outlying areas, and natives often traveled to Barstow for employment with the railroads. (Courtesy of the Mojave River Valley Museum.)

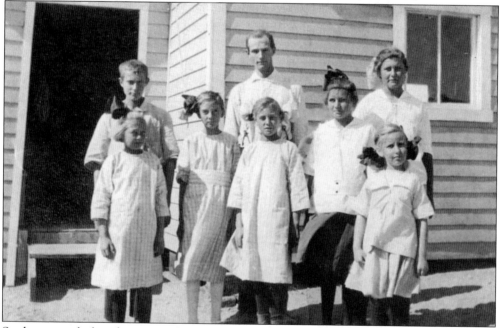

Students pose before their new schoolhouse on Soapmine Road in this 1910s photograph. Fish Pond School was built near the river in Barstow about 1912. When the Mojave River would flood, the schoolhouse was used as a shelter for nearby residents. (Courtesy of the Mojave River Valley Museum.)

North Americans of Latin descent, some from New Mexico Territory, founded successful ranchos around the Barstow valley where abundant water could be found near the Mojave River. Pictured in 1952 are the Ramirez, Hughes, and Ballejos families. Donato Ballejos, in black cowboy hat, helped to establish Trail of the Pioneers Monument. (Courtesy of the Mojave River Valley Museum.)

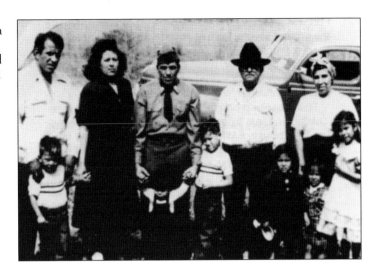

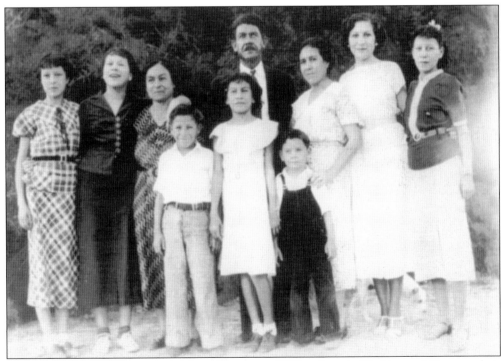

The Arredondo family emigrated from Mexico in 1915 and made Hinkley and Barstow their family homes. Pictured here are, from left to right, (first row) Ramon, Annie, and Ruben; (second row) Fela, Paula, Lupe, Jose, Hermenia, Elvira, and Minnie. Jose worked as a section foreman for the Santa Fe Railway. Paula became matron of the Barstow jail for many years. (Courtesy of the Mojave River Valley Museum.)

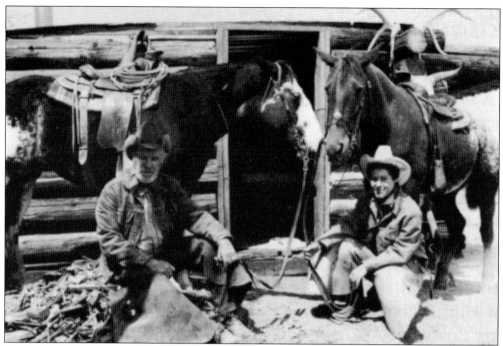

In this early 1900s photograph, Lee Berry (left) and Cathy Westmoreland take a rest from cowboying. Lee and his wife, Mary, started the ranch in the 1940s. One of the largest ranches in the area, it was headquarted eight miles south of Barstow on Highway 247. Lee built a bar for his cowhands and friends. Three decades later, they sold the entire ranch, keeping only the house and land where they lived. The property is now a rambling museum of ranching relics and has become a popular off-road-vehicle-riders' haven. (Above, courtesy of the Mojave River Valley Museum; below, courtesy of the Atkinson collection.)

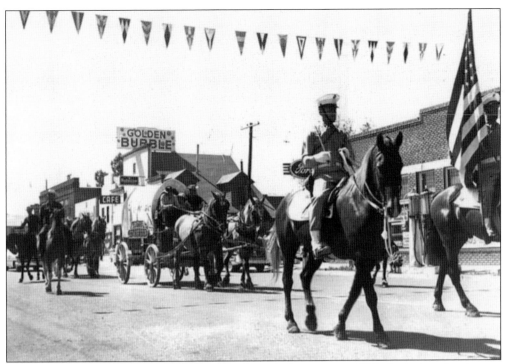

Barstow's annual Rodeo Days parade marches through downtown in 1961. Agricultural endeavors such as hay farms and cattle and horse ranches were an integral part of the landscape around Barstow. They still abound near the Mojave River, where underground water can be abundant. Rodeos, parades, and myriad other Western-themed events have always been a part of Barstow's heritage since the 1800s. (Both, courtesy of the Mojave River Valley Museum.)

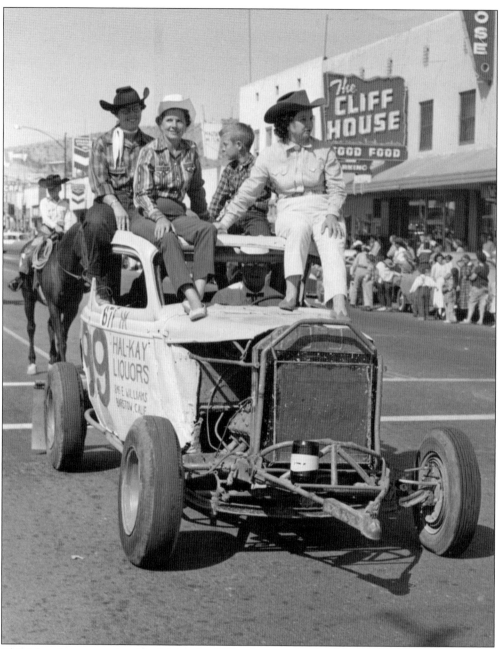

This jalopy has a capacity ridership in this 1960s photograph of Barstow's rodeo parade. The entire town of Barstow and communities from all around the area would attend this annual parade and the rodeo events to follow at the rodeo grounds. Usually, the parade participants on horseback would simply continue into the rodeo arena and another parade around the arena, called the grand entry, led by the year's rodeo queen. The Cliff House, a popular establishment for decades in Barstow, is seen behind the riders. It was a gathering spot for travelers and local residents alike. (Courtesy of the Mojave River Valley Museum.)

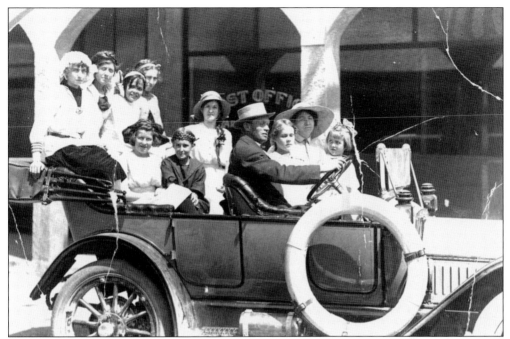

This photograph depicts a typical Barstow family departing from the post office. Their luxurious automobile is filled to capacity. The driver is the manager of the nearby Harvey House in the Barstow Depot, and the image dates back to when the town was located at the rail yard before moving up the hill to Main Street. (Courtesy of the Mojave River Valley Museum.)

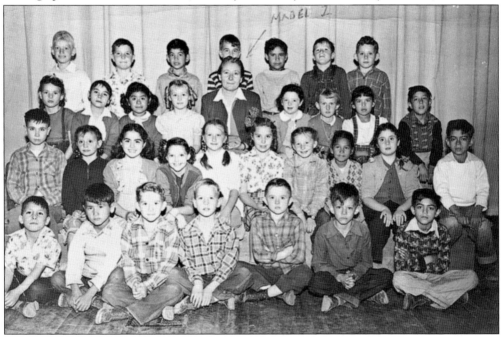

Students sit for a classic classroom photograph at Hutchison School in 1948. The elementary-level school was located at Second and Hutchison Streets, just north of downtown Barstow near the First Street Bridge. The buildings now house Central High School. (Courtesy of the Walde family.)

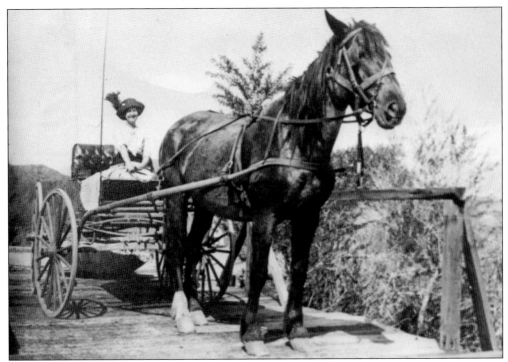

Emma Miller poses with her horse and buggy on a wooden bridge in this photograph from about 1910. Automobiles were beginning to show up in the desert as adventurous drivers bounced them westward over pitted and pot-holed roads into and out of Barstow, the burgeoning junction of several major highways. (Courtesy of the Mojave River Valley Museum.)

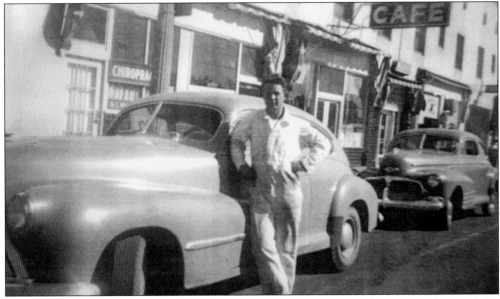

Luther Friend strikes a pose along Main Street in this iconic 1940s photograph. Automobiles had become so popular by this time and were streaming through Barstow on Route 66 at such a rate that service and repair stations had become some of the most profitable businesses in town. (Courtesy of the Barstow Route 66 Museum.)

The North First Street Del Taco was previously a Taco Tia until taken over by the owners of Del Taco around 1951. The Hackbarth family proceeded to make this location into an extremely popular gem in the Del Taco chain, which holds its fame to this day. (Courtesy of the Mojave River Valley Museum.)

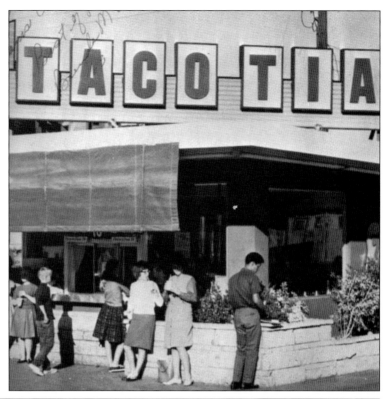

Pictured here in the 1930s is the Forum Theater along Barstow's then thriving Main Street. The feature film is a 1935 western starring famous cowboy hero Tom Mix in his last major movie. Children and adults alike flocked to these theaters before televisions were common household appliances. (Courtesy of the Mojave River Valley Museum.)

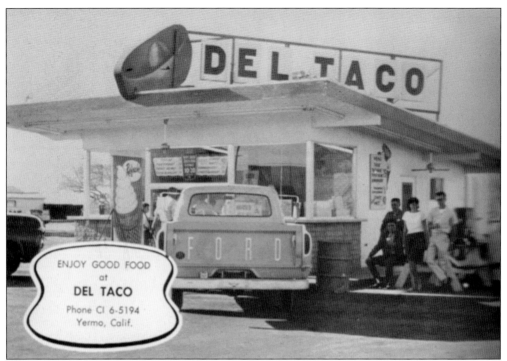

ENJOY GOOD FOOD
at
DEL TACO
Phone CI 6-5194
Yermo, Calif.

Pictured in this advertisement from a 1963 Barstow High School yearbook is the first Casa Del Taco establishment, opened by Ed Hackbarth in Yermo in 1961. Ed was joined by his brother Tony, David Jameson, and Dick Naugles in 1966, opening Del Tacos around the Inland Empire. (Courtesy of the Mojave River Valley Museum.)

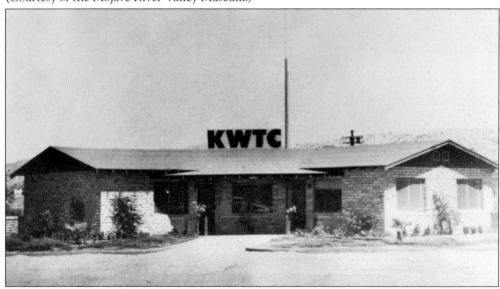

KWTC was Barstow's first radio station, and this original building dates back to the 1940s. In 1947, the wires attached to the antenna snapped in the powerful desert winds. It happened during the time the new city council was about to vote on cityhood, but the radio crew was able to broadcast during repairs that Barstow would indeed become a city. (Courtesy of the Mojave River Valley Museum.)

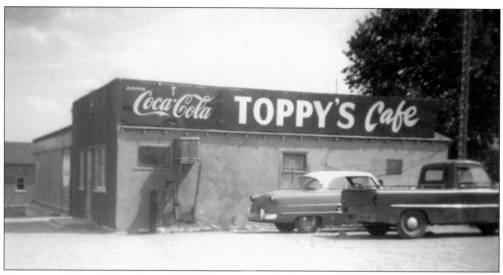

The story of the little café in this 1958 photograph above is typical of many such businesses along the original route of Highway 66 through Barstow. Opened in west Barstow by coauthor Christine Toppenberg's family in the 1950s, Toppy's Cafe thrived until the new interstate freeway came through the area in 1960. The new Interstate 15 bypassed Barstow and all of the remaining miles of Route 66 and its small businesses. Pictured below, the Katz Bar and Grill to the east along Barstow's Main Street was a popular bar and grill and sometime dance hall and operated for 50 years before closing after the new freeway reduced downtown traffic by 90 percent. (Above, courtesy of the Toppenberg collection; below, courtesy of the Mojave River Valley Museum.)

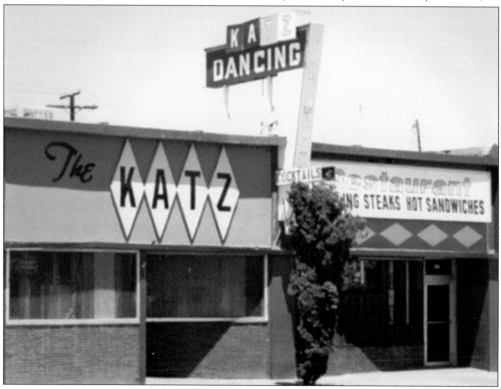

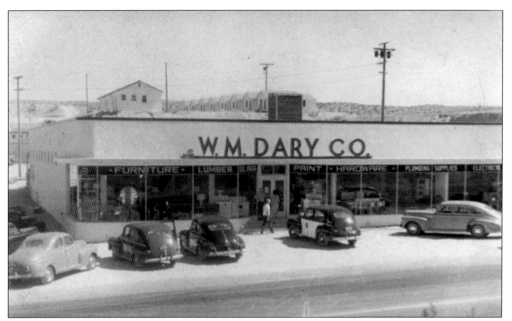

The W.M. Dary Company was one of the most prominent buildings and businesses during Barstow's boom development. Started in 1946, the business lasted through the 1960s. This major lumber supplier was located on US Highway 66, Barstow's Main Street, at the top of the hill. In this 1948 photograph, behind Dary are apartments built during World War II. (Courtesy of the Teague family.)

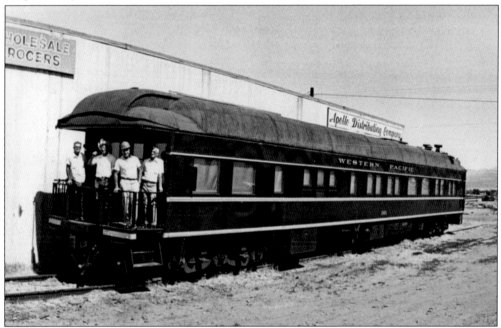

Barstow Station was built by Fred Rosenberg in 1975 using vintage railroad cars sitting on unused railroad tracks alongside active railways. Pictured here in the 1970s, the owners of the project lived in this vintage railroad car while putting together the project. (Courtesy of the Rosenberg collection.)

This photograph was taken on dedication day for the new Barstow Station in 1975. Bill Rosenberg (in apron) and dignitaries pose on the steps of one of the railroad cars. The success of the endeavor has never faltered. Now, sometimes, 65 tour buses in a day bring tourists from across the country and around the world to explore the old train cars and the businesses inside. (Courtesy of the Rosenberg collection.)

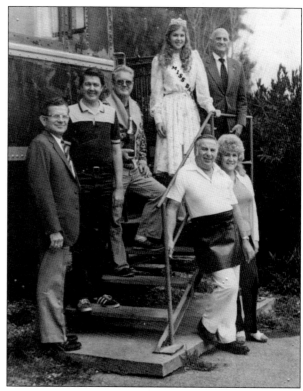

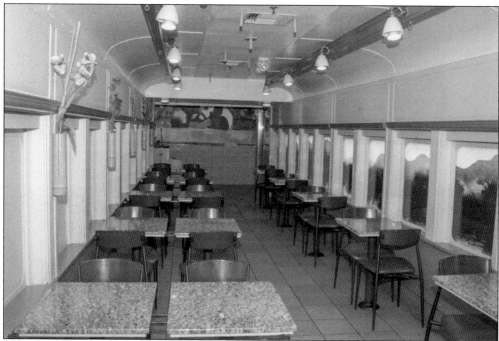

The first and at one time largest and most successful McDonald's restaurant was incorporated inside the railroad cars and became the famous chain's busiest site. There are shops and food services inside where one can sit inside an old railroad car. (Courtesy of the Atkinson collection.)

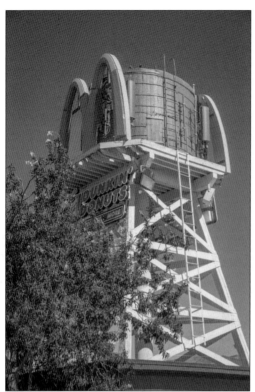

The Poes Water Camp Tower was transferred to the Barstow Station. The station was built of vintage railroad cars, tracks, ties and other pieces of rail yard ruins to create a popular stop for Route 66 and new interstate travelers. (Courtesy of the Atkinson collection.)

This vintage photograph shows the positions of the old railroad cars that form the lower floor of the Barstow Station. Passageways were built between cars, and sightlines are open through several cars at once. Stairways extend up from railroad tracks into a rambling second floor housing offices and five transmitting radio stations. (Courtesy of the Rosenberg collection.)

When it was erected in the 1930s, the 125-foot Richfield Tower at the west end of Main Street in Barstow welcomed travelers from all points east. The Beacon Hotel and Café complex offered up luxurious gardens surrounding air-conditioned rooms until 1957, when the new freeways diverted traffic away. (Courtesy of the Mojave River Valley Museum.)

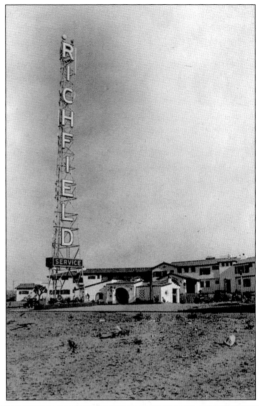

This Burton Frasher postcard from the 1940s shows a view of the magnificent gardens that were part of the Beacon Tavern landscaping. The garden included this wagon, a reminder of transportation of the past, and the famous rock arch, used for many a wedding, can be seen behind the wagon. (Courtesy of the Mojave River Valley Museum.)

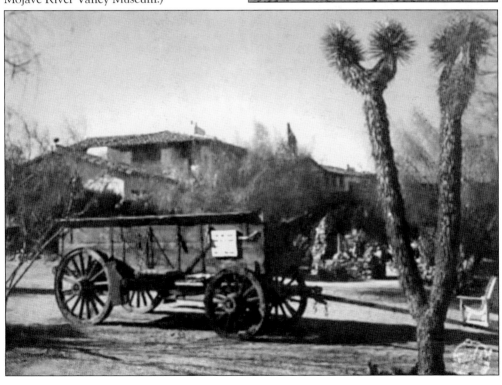

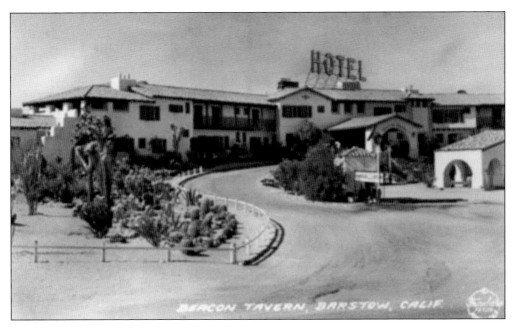

Architects Wilson and Merrill were contracted to design the Barstow Tavern and Hotel. They created a design of Spanish haciendas with tile roofs, balconies, and archways meandering through lush grounds and cactus gardens. Spanish-styled rooms and furnishings, tiled bathrooms, steam heating, and modern air-cooling systems made the facilities highly desired and appreciated by hot travelers. The Beacon Café served excellent fare. The full-service automobile garage and Richfield gas station was an added amenity. Opened in 1930, the Barstow Beacon saw its success come to an end with the construction of the new bypassing freeway in the late 1950s. The lovely buildings are now only found printed on Frasher vintage postcards like these and in the memories of Barstow old-timers. (Both, courtesy of the Mojave River Valley Museum.)

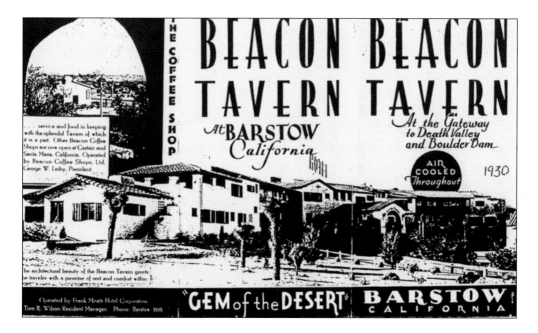

This graphic capture above of a vintage 1930 postcard relays the essence of the luxurious resort. From the motto "Gem of the Desert" to the description of the Beacon Tavern as the gateway to Death Valley and Boulder Dam, the card emanates excitement for travelers along Route 66. The phone number listed at the bottom of the card is "Barstow 266." After the hotel corporation that owned the Beacon chain lost out to the Depression economy, the Richfield letters came off of the tower to be temporarily replaced as pictured below by Beacon Bowl signage, and in later years the precious gem of a complex completely disappeared. (Both, courtesy of the Mojave River Valley Museum.)

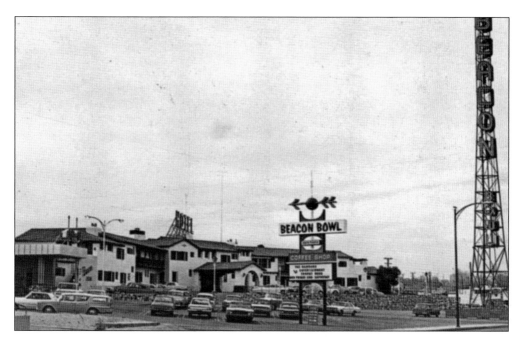

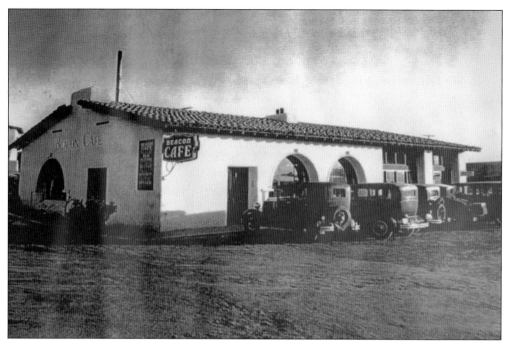

The Beacon Café is part of the luxurious Beacon Tavern complex built to enhance the resort that was part of a planned chain of such traveler havens. The owners wanted to create a rest stop leaving nothing out so travelers might stay longer and simply enjoy the extended stopover. (Courtesy of the Mojave River Valley Museum.)

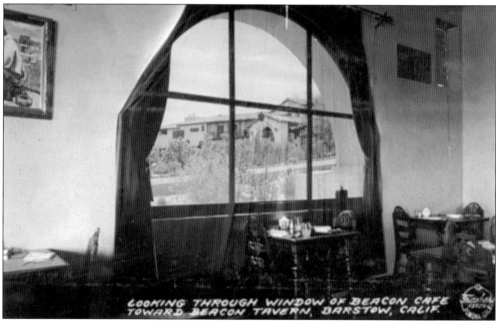

Rooms in the Beacon Hotel certainly left nothing to be desired. The design of the buildings in a Spanish villa style was continued inside in common spaces and private suites. Guests enjoyed the complete royal treatment, such that Hollywood royalty in residence was not rare. (Courtesy of the Mojave River Valley Museum.)

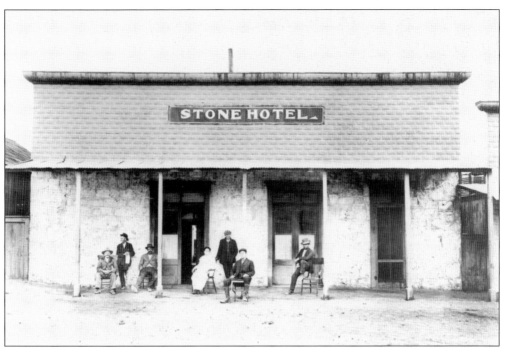

Customers gather for an evening breeze at the Stone Hotel in Daggett. Built in 1875 and operating for more than 100 years, this two-story stone building has been designated as a registered landmark. It was first known as the Railroad Eating House when Daggett was an important stop on the new rail lines coming into Barstow. (Courtesy of the Mojave river Valley Museum.)

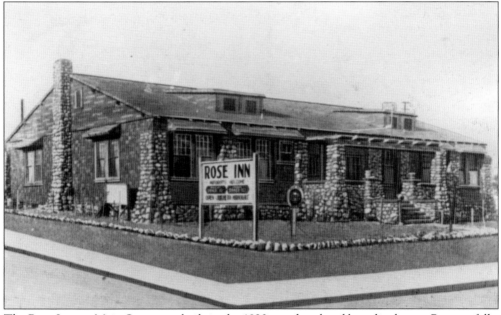

The Rose Inn on Main Street was built in the 1920s as a hotel and boardinghouse. Barstow folks enjoyed its cozy atmosphere, and many local events, including weddings and high school proms, were held there. Long closed, the building remains, albeit with a new facade. (Courtesy of the Mojave River Valley Museum.)

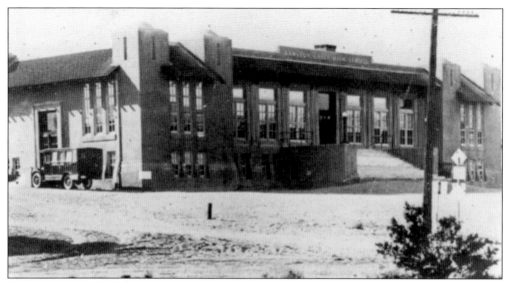

This lovely old redbrick building was erected on Main Street in 1918 to house Barstow Union High School. The last class to graduate there was in 1938. The building was later demolished, and the El Rancho Hotel and Restaurant was constructed there. (Courtesy of the Mojave River Valley Museum.)

The Hillside Apartments were built in 1911 by Reece Dillingham and originally named after him. They sat above the old National Trails Highway. They were also known as Van Ness Apartments and Foley Apartments. The complex is the longest continually running local business in Barstow. (Courtesy of the Atkinson collection.)

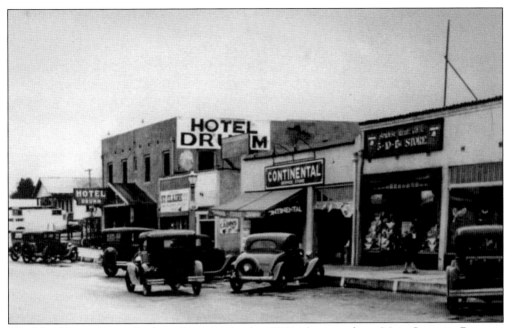

The Hotel Drumm overshadows the street in this 1910s photograph on Main Street in Barstow. The hotel is just down the street from the new firehouse, built to protect just such structures. Automobiles have just begun to show up in Barstow, but Route 66 is a few years away. (Courtesy of the Mojave River Valley Museum.)

This vintage photograph is intriguing for the sign that advertises rooms for $1 and the movie marquee advertising that the 1948 movie *The Swordsman* is playing. Young men hanging out on the street are well dressed in the style of the times. (Courtesy of the Mojave River Valley Museum.)

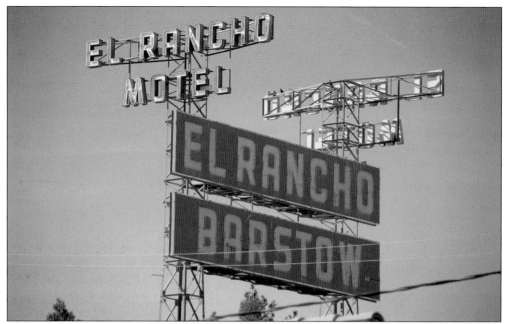

In the heart of Old Barstow, where Route 66 passes through, nestles the El Rancho Motel. Built entirely of railroad ties from worn-out rail lines, it has been in almost continuous operation to this day. Rooms are named after movie stars who stopped overnight here on their way to and from Las Vegas, including Marilyn Monroe and Cary Grant. (Courtesy of the Atkinson collection.)

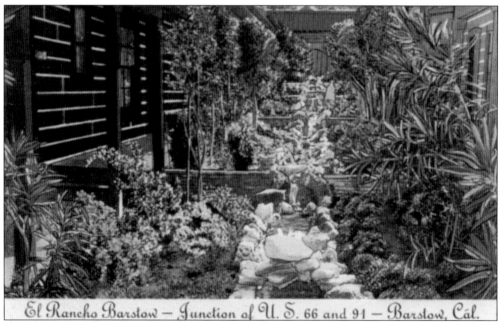

El Rancho Barstow — Junction of U. S. 66 and 91 — Barstow, Cal.

This vintage postcard shows the gardens at the El Rancho Motel as they flourished in the 1940s. The popular motel is part of the colorful heritage of Barstow and its current role in the preservation of Route 66. Barstow is one of the few downtowns through which maintained stretches of the world-famous highway still exist. (Courtesy of the Mojave River Valley Museum.)

The El Rancho Motel Coffee Shop was built in 1944. It was another Route 66 icon constructed of railroad ties when older rail lines were replaced with alternate rail routes on newer tracks. The café sat on Main Street at the intersection of Route 66 and Highway 91 from Las Vegas. (Courtesy of the Mojave River Valley Museum.)

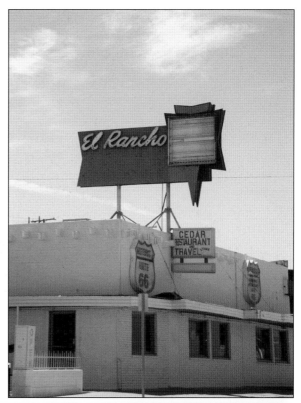

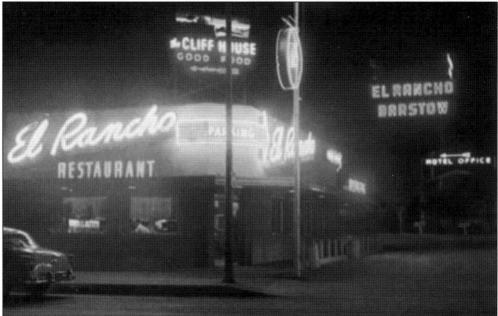

Another classic vintage photograph of the El Rancho at night lends glamour to an already-popular stopover on Barstow's lively Main Street. The street is also Route 66, and glitz is the name of the game that inspired the famous Bobby Troup song about kicks on Route 66. (Courtesy of the Mojave River Valley Museum.)

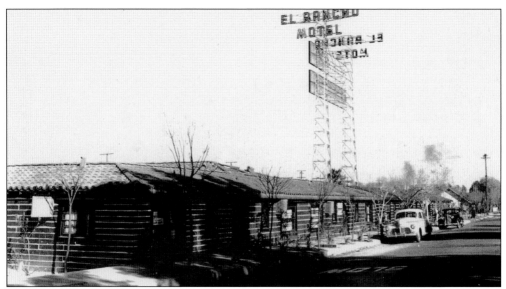

This 1950s photograph really shows off the look of the original El Rancho buildings, which were constructed with abandoned Tonopah and Tidewater Railroad ties. Native American stonemasons were brought in from Window Rock, Arizona, to lay the flagstone walkways. (Courtesy of the Mojave River Valley Museum.)

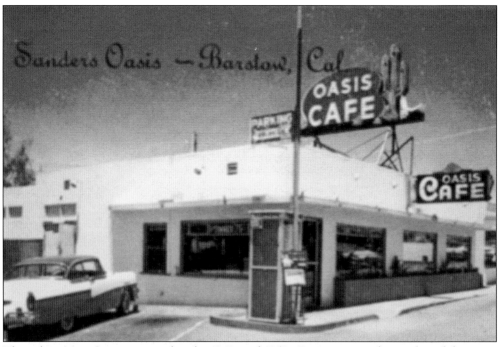

This is how Main Street appeared in the 1940s and 1950s. Barstow sported a number of charming eateries for traveling guests. The Oasis Café in this photograph was popular for many years before it was replaced by another café and the building was demolished. (Courtesy of the Mojave River Valley Museum.)

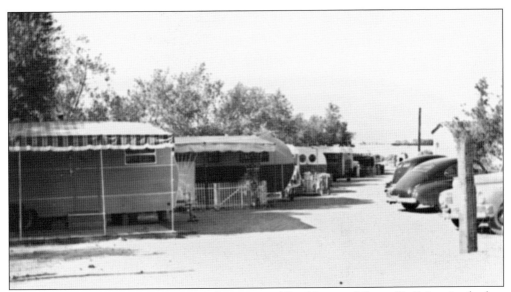

The Triangle Trailer Park was built at the corner of Bradshaw and Santa Fe Drives in the late 1950s by the Walde family. The tree-shaded spaces and green lawn attracted many folks arriving from the Midwest with their trailers in tow, looking for work in a growing Barstow. (Courtesy of the Walde family.)

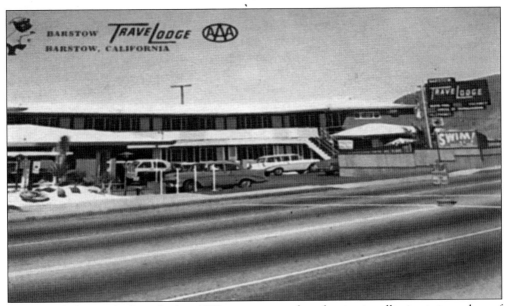

The Travelodge was built in the late 1950s to accommodate the continually growing numbers of travelers on Route 66 through Barstow. The traffic continued to increase until the new interstate freeway was routed around downtown, and motels like this one lost business. (Courtesy of the Mojave River Valley Museum.)

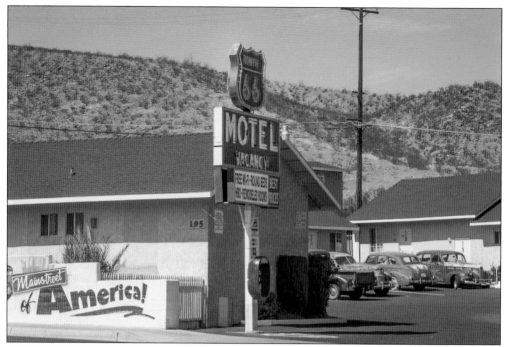

Barstow's Route 66 Motel was built in 1922. The new owners have refurbished the formerly nondescript motel into a Mother Road showcase with antique cars between the cottages and round beds in rooms. It is Route 66 of the 1950s reincarnated. (Courtesy of the Atkinson collection.)

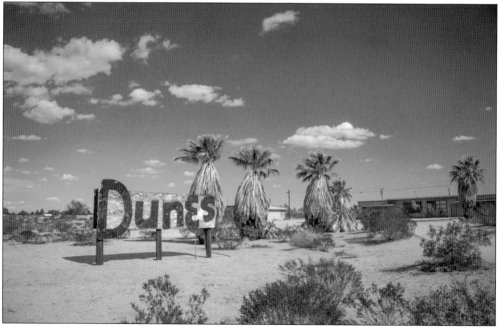

Ghostly buildings, palm trees, a swimming pool, and signage for the Dunes Motel west of Barstow on old Route 66 still stand waiting for renovation. The Dunes was a popular overnight rest stop in the 1950s and 1960s for travelers on a long, hot drive. Stables sheltered saddled horses ready for a ride through endless desert acres surrounding the ranch. (Courtesy of the Atkinson collection.)

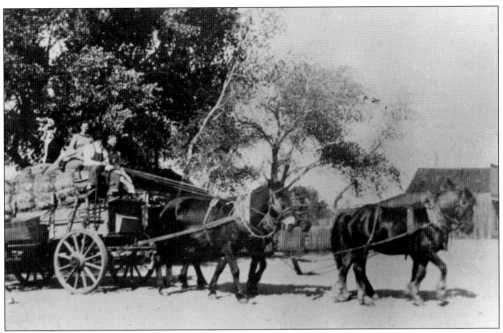

The farmer and boys on this wagon have probably just loaded this wagon with fresh bales of hay to make a delivery. They are driving a team with mules behind and horses in front, a combination used quite often that took advantage of mules' strength and horses' dispositions. (Courtesy of the Mojave River Valley Museum.)

The Pioneer Meat Market was established in the 1890s on Santa Fe Street in Daggett. When it was sold to the Ryerse family, the name was changed to the H.C. Ryerson Store. Later, it was called Scott's Market. The store's claim to fame was its service of converting gold dust to currency. It is now the Desert Market. (Courtesy of the Mojave River Valley Museum.)

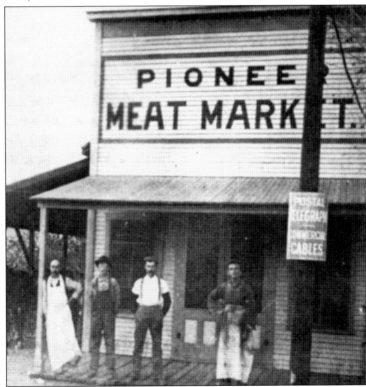

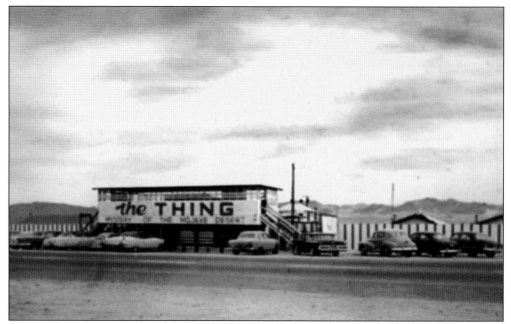

The Thing was the creation of attorney Thomas Binkley Prince. He and his wife, Janet, opened this roadside attraction and curio shop in the 1950s between Barstow and Baker. Expansion of the interstate highway took their building, so in 1965 they moved the Thing to Arizona. (Courtesy of the Mojave River Valley Museum.)

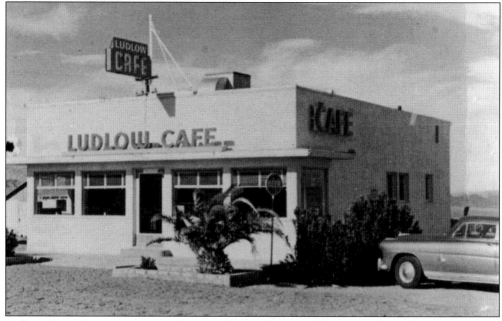

Ludlow, formerly an important rail station, lies to the east of Barstow. The Ludlow Cafe in this vintage photograph was built in 1948. The lumber from the defunct Tonopah and Tidewater Railroad was put to good use in the walls and support timbers. Ludlow's rail station and most businesses now stand abandoned and are featured in thousands of tourist photographs. (Courtesy of the Mojave River Valley Museum.)

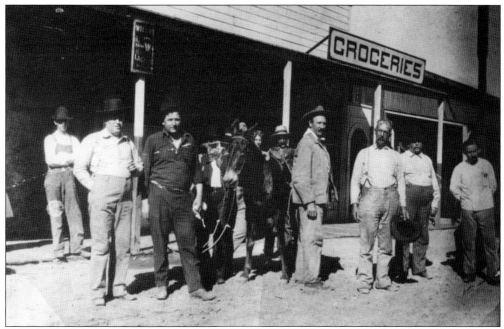

Gathering around the Daggett Hotel and General Store for this 1905 photograph is a group being presided over by the locally famous Death Valley Scotty, dressed in black and holding a mule's reins. He visited often to collect supplies for his castle and mining operations. (Courtesy of the Mojave River Valley Museum.)

Lloyd Lyon calls a square dance at the Hinkley Grange around 1938. Lloyd and Hazel Lyon traveled from Kansas to Barstow to take up work on the Waterman Ranch beside the Mojave River in 1937. The Grange in nearby Hinkley was a center of area social events. (Courtesy of the Lyon and Shafer families.)

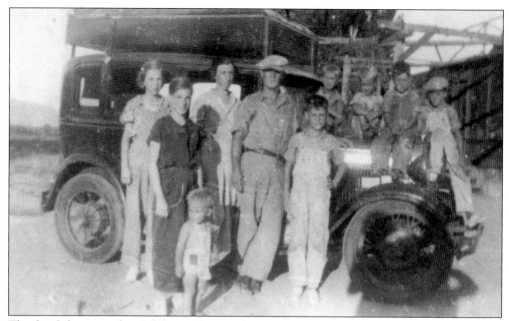

This family has arrived in California after traveling six days in one automobile with their combined belongings on top. They are, from left to right, Phyllis Lyon, Virginia Lyon, Hazel Lyon, Lloyd Lyon, and Elwin Lyon. Richard and Arvey Lyon, Javier Devine, and Warren Lyon are on the hood, with Cliff Devine in foreground. (Courtesy of the Lyon and Shafer families.)

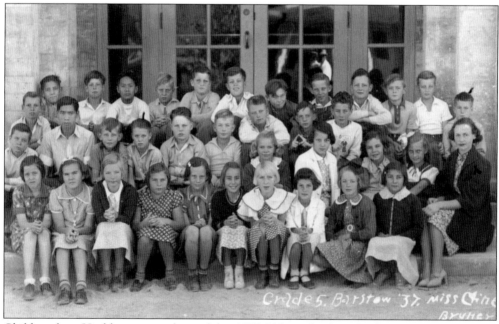

Children from Hinkley are members of this 1937 fifth grade class. Students from surrounding communities by that time usually had buses as transportation to school miles away in Barstow. Many children worked on their parents' farms, so they traveled through the grades at an uneven pace, as evidenced by a few larger students seen in this group. (Courtesy of the Lyon and Shafer families.)

Remnants of the Bar Len Drive-In on Route 66 near Barstow are still standing in this 1980 photograph. When the popularity of drive-in theaters waned, this and most theaters like it closed. The Bar Len site was demolished to make way for the new section of Lenwood Road. (Courtesy of the Atkinson collection.)

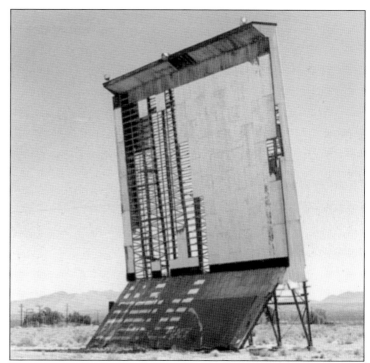

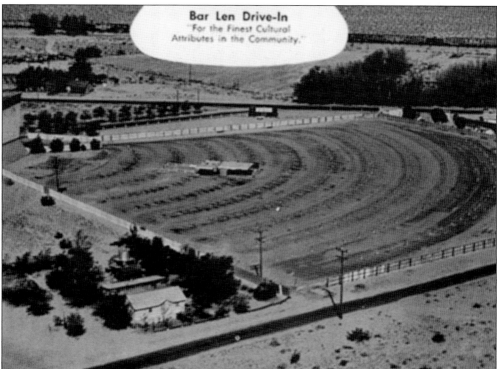

In the heyday of drive-in theater popularity, the Bar Len was a center of nighttime movie entertainment. In this 1950s advertisement, the AT&SF Railway is visible across the top, with Route 66 bordering the drive-in's north side. (Courtesy of the Mojave River Valley Museum.)

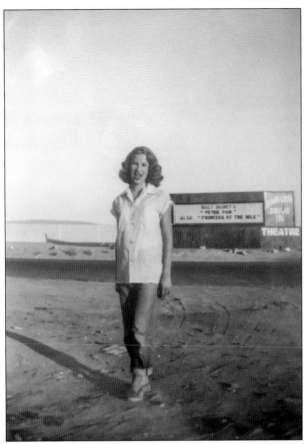

Bar Len Drive-In theater fan Janice Wise poses for this 1953 photograph in front of the drive-in's marquee. Disney's *Peter Pan* was playing. The theater was named for the two towns it was between, Barstow and Lenwood. Remote desert areas did not receive first-run movies for about six months or more after their premieres. In the photograph below, the Wise sisters pause from a day of swimming at a typical homestead or farm reservoir near Route 66. (Courtesy of Judy Wise Family.)

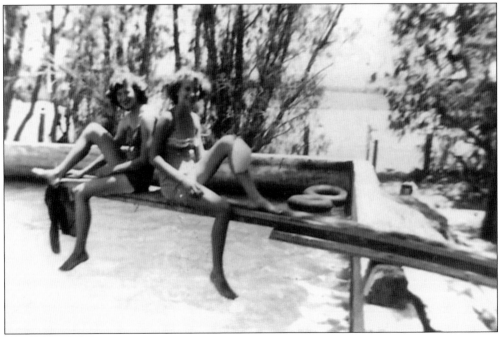

Nine

RIVER, FLOODS, AND FIRE

The "Mighty Mojave" is the somewhat ironic moniker often used when Mojave Desert dwellers refer to the river that flows underground most of the time through their high desert communities. It is a river that has drawn people to it for centuries, beginning with the earliest known native tribes who depended on it for water to survive. They formed their camps where the water came aboveground and avoided stretches of the river that sank under the sand where the Mojave flowed out of sight but nevertheless on its way.

The way of the Mojave River was to gather up water from streams of runoff in the San Bernardino Mountains to the south and flow north and northeast through Hesperia, Victorville, Oro Grande, Helendale, Lenwood, Barstow, past military garrisons, and in a rainy season providing enough water, on out to the bone-dry desert near Baker, to finally sink into and fill up a place called Soda Lake. If rains were even heavier, the water may hold together long enough to get to another waiting sink, Silver Lake.

But when rains were heavy, the river raged down its pathway, taking out bridges, flooding into riverside settlements, taking farm animals, buildings, and, later, even cars with it for a wild ride. In Barstow, it flowed a mile wide.

Erma Pierson, high desert historian, loved that river and wrote her paean to it. Clifford J. Walker, one of Barstow's primary historians, wrote at length of its importance in his book *Mojave River Trail*. Local mythology, which at one time was even taught in local schools, holds that the Mojave River is the only river that flows northward, but in reality it is one of about 100 such northbound rivers.

Over the decades, even before explorers mapped the Mojave River, people followed the Mojave River to Barstow, where many found what they were looking for and stayed.

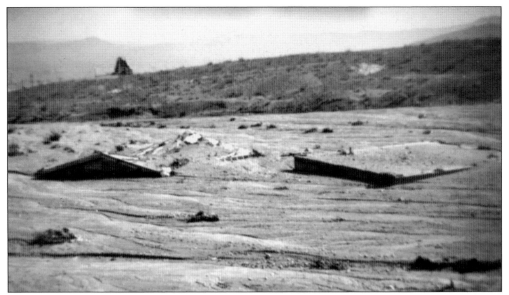

A lesson learned quickly by homesteaders building their tiny homes on the slopes above the Mojave River was about flash flooding. When rain falls miles away in high mountains, the run-off on a sunny day in the desert below gathers into raging floods, quickly taking structures apart. This photograph was taken in 1954 from the coauthor's homestead cabin. A roof and foundation is all that remains of a neighbor's cabin. (Courtesy of the Toppenberg collection.)

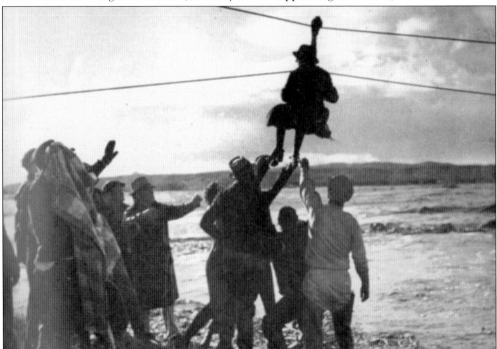

Following the initial maelstrom of the "Mojave Desert Flood of the Century," residents began efforts to reach those stranded on rooftops and a group isolated on a strip of land midstream. With the implementation of a breeches buoy and the block and tackle bridge in this 1938 photograph, they were successful. (Courtesy of the Mojave River Valley Museum.)

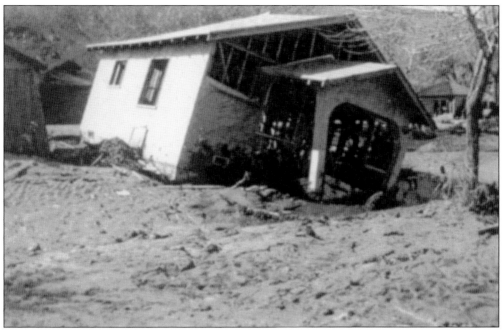

These two Barstow-area photographs illustrate devastating results of the 1938 flood. A small house landed far from its foundation, demolished beyond hope of rehabilitation. The automobile below was swept off the flooded banks into the river. The geological records at the Barstow stream-gauging station reported this as the largest Mojave River flood of the 20th century. The floods were a result of an El Niño storm that also caused flooding damage throughout Southern California. Measured at Victorville 35 miles away, the deluge in the Mojave River sometimes reached more than 70,000 cubic feet per second. (Both, courtesy of the Mojave River Valley Museum.)

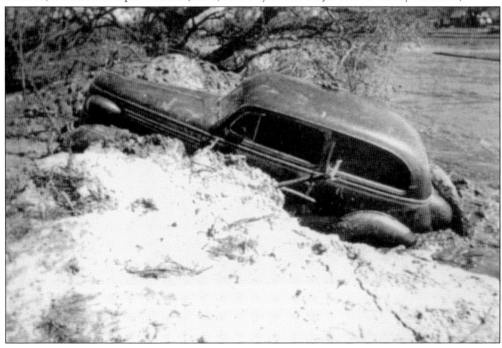

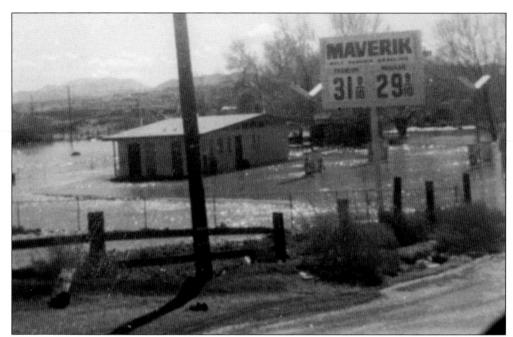

No one was able to get in to purchase the 32¢ gasoline at this Maverik station on Irwin Road when the Mojave River was at this high flood stage. Floods were not unusual during a heavy rain in the mountains far to the south of Barstow. (Courtesy of the Mitchell Collection, Mojave River Valley Museum.)

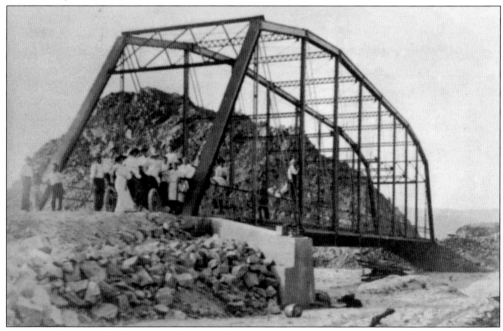

Versions of attempts to bridge the Mojave River varied in their effectiveness. Folks in this vintage image are gathered on the south bank of the overflowing river to view damage to the River Bridge. The washed-out section appears to be on the end reaching toward Buzzard Rock, looming behind the bridge. (Courtesy of the Mojave River Valley Museum.)

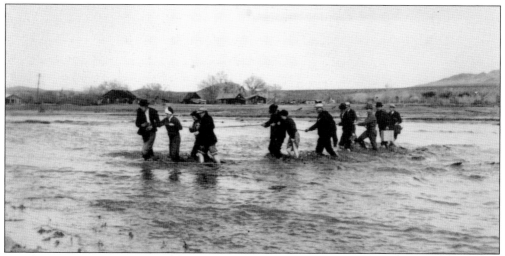

Hundreds of people in the Barstow area lost their homes, farms, and animals in the Great Flood of 1938. Town buildings were high enough to avoid major flooding, although many lowland businesses were demolished, as were roads and smaller bridges. The deluge was called a 100-year flood. (Courtesy of the Mojave River Valley Museum.)

Built in 1932, this bridge and old Highway 91 brought myriad travelers into Barstow from Las Vegas on their way to Los Angeles and Hollywood. The Mojave River, dry most of the year, runs full like this only after occasional heavy rains flowing from the mountains far away to the south. (Courtesy of the Mojave River Valley Museum.)

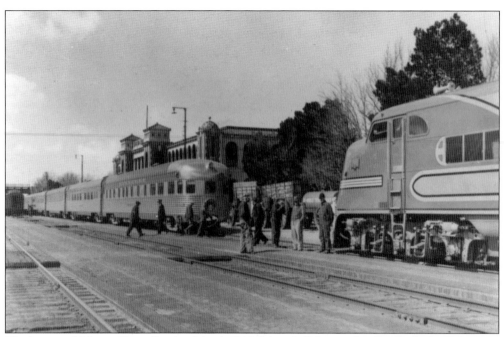

The historical Mojave River flood in March 1938 delayed all forms of traffic. Both the El Capitan and the Super Chief in this vintage photograph sit stranded in Barstow due to flooding on the tracks. A 20-mule team pulling a heavy freight wagon also sits visible between the trains, waiting for the muddy roads to dry out. (Courtesy of the Mojave River Valley Museum.)

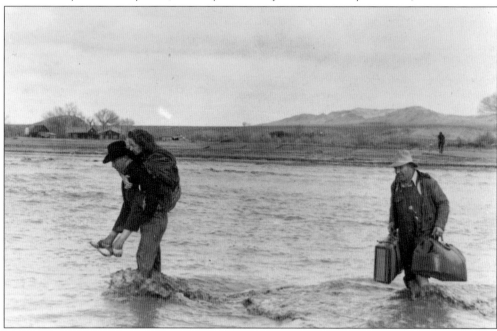

The Great Flood of 1938 caused trouble all over Southern California. These Barstow residents are taking only what they can carry and crossing a wide but shallow part of the overflowing river and will take shelter at neighbors' homes and at churches in the main part of town, which is slightly uphill from the river. (Courtesy of the Mojave River Valley Museum)

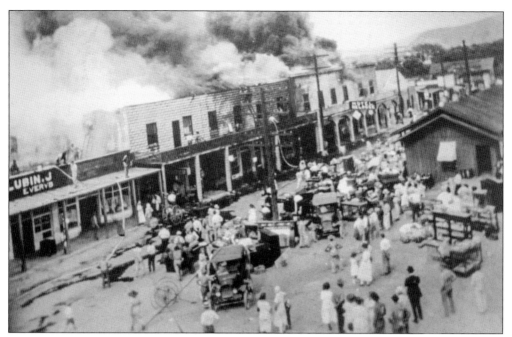

The fire of 1921 was one of several fires that destroyed buildings, including the original Hotel Melrose seen on the left. The double roof on the building to the right may have saved that building. Fire insurance was not available until after the city had organized fire protection. (Courtesy of the Mojave River Valley Museum.)

The Barstow Fire District was formed in 1926 following several serious fires in Old Town. The first firehouse on First Street was dedicated in 1939 with a bronze plaque inscribed with a pledge to the "Preservation of Truth, Liberty and Toleration." Pictured here are trucks and crews in 1940. (Courtesy of the Mojave River Valley Museum.)

Coauthor Christine Toppenberg takes pleasure in reflecting the scenes, stories, legends, and legacy of the Mojave River Valley through her written words. (Courtesy of the Atkinson collection.)

Coauthor Donald Atkinson takes pleasure in reflecting the scenes, stories, legends, and legacy of the Mojave River Valley through his camera lens. (Photograph by Gail Hobson.)

BIBLIOGRAPHY

Keeling, Patricia Jernigan. *Once Upon a Desert, a Bicentennial Project*. Barstow, CA: Mojave River Valley Museum Association, 1976, 1994.

Leadabrand, Russ. *A Guidebook to the Mojave Desert of California*. Los Angeles: Ward Ritchie Press, 1966.

Moon, Germaine L. Ramounachou and Clifford J. Walker, Patricia A. Schoffstall, and Steve Smith. *Barstow Depots & Harvey Houses*. Barstow, CA: Mojave River Valley Museum Association, 1980, 2004.

Peirson, Erma. *The Mojave River and Its Valley*. Cleveland: A.H. Clark Company, 1970.

Schoffstall, Patricia A. *Mojave Desert Dictionary Second Edition*. Barstow, CA: Mojave River Valley Museum, 2014.

Swisher, John M. *Bits 'N Pieces of the Mohahve Desert's Weathered Past*. Barstow, CA: John M. Swisher Publisher, 1995.

Discover Thousands of Local History Books
Featuring Millions of Vintage Images

Arcadia Publishing, the leading local history publisher in the United States, is committed to making history accessible and meaningful through publishing books that celebrate and preserve the heritage of America's people and places.

Find more books like this at
www.arcadiapublishing.com

Search for your hometown history, your old stomping grounds, and even your favorite sports team.

Consistent with our mission to preserve history on a local level, this book was printed in South Carolina on American-made paper and manufactured entirely in the United States. Products carrying the accredited Forest Stewardship Council (FSC) label are printed on 100 percent FSC-certified paper.